DATE DUE

POP ART

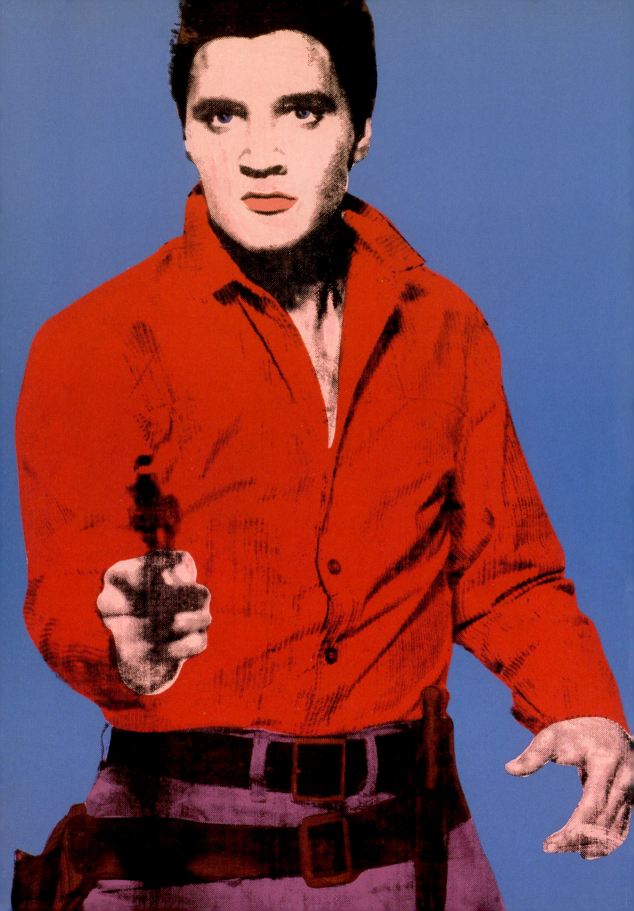

POP ART

DAVID McCARTHY

CAMBRIDGE
UNIVERSITY PRESS

PUBLISHED BY THE PRESS SYNDICATE OF THE
UNIVERSITY OF CAMBRIDGE
The Pitt Building, Trumpington Street, Cambridge
United Kingdom

CAMBRIDGE UNIVERSITY PRESS
The Edinburgh Building, Cambridge CB2 2RU, United Kingdom
http://www.cup.cam.ac.uk
40 West 20th Street, New York, NY 10011-4211, USA
http://www.cup.org
10 Stamford Road, Oakleigh, Melbourne, 3166, Australia
Ruiz de Alarcón 13, 28014 Madrid, Spain

First published by Tate Gallery Publishing Ltd, London 2000

Cover designed by Slatter-Anderson, London
Book designed by Isambard Thomas
Typefaces/Monotype Centaur (9/10.5 pt)
and Adobe Franklin Gothic
System (Apple Macintosh) [IT]

Printed in Hong Kong by South Sea International Press Ltd

A catalogue record for this book is available from the British Library

Library of Congress Cataloguing-in-Publication Data is available.

Measurements are given in centimetres, height before width,
followed by inches in brackets

Cover:
Roy Lichtenstein,
Whaam!, 1963 (detail of fig.49)

Frontispiece:
Andy Warhol,
Elvis I and II, 1964 (detail of fig.42)

ISBN 0-521-79014-X

*To my parents, Ruth and Tom, who took me
to museums*

Acknowledgements

Books are rarely written without the assistance
and support of many dedicated and talented
individuals, and this book is no exception.
It is a pleasure to acknowledge their help.
My thanks to Beatrice Rehl at Cambridge
University Press for encouraging me to write the
study; to Simon Wilson, Liz Alsop, Pernilla
Pearce, Emma Neill, Celia Clear, Rob Airey and
Tom Chandler at the Tate Gallery for hours of
advice and assistance; to Christopher Poke and
Michelle O'Malley for logistical support and
several evenings of camaraderie in London;
to Reebee Garofalo for sharing his expertise and
enthusiasm for post-war popular music; and to
Marina Pacini, for more than I can say.

Contents

I

1
Richard Hamilton

*Just what is it that
makes today's homes
so different, so
appealing?* 1956

Collage
26 × 25
(10¼ × 9¾)
Kunsthalle Tübingen,
Prof. Dr. Georg Zundel
Collection

A NEW AESTHETIC SENSIBILITY

It is entirely fitting that the post-war art movement most readily identified
with signs, consumerism and mass communications found one of its first
– and perhaps most famous – images in the form of an advertisement.
Richard Hamilton's collage *Just what is it that makes today's homes so different,
so appealing?* (fig.1) was initially conceived as a poster and catalogue illustration
for the Independent Group's 1956 exhibition, *This is Tomorrow*, staged at the
Whitechapel Art Gallery in London. The question posed by Hamilton was
easy enough to answer. Today, homes are different and appealing because
recent technologies, including talking films, television and reel-to-reel tape
recorders, offered escape inside and outside of the home, while domestic
conveniences, such as vacuum cleaners and tinned ham, freed consumers
to pursue more hedonistic pleasures. The couple occupying today's home
seems as glamorous and well designed as the objects around them. His turgid
physique swells confidently to dominate the space of the open floor, while
her trim, yet ample, presence graces the overly large sofa serving as her
pedestal. Together they provide the most engaging and amusing components
in a composition overloaded with artefacts designed to capture our attention
and deliver a simple message. In short, a consumer fantasy world available
for the right price promised escape from the drudgery of post-war life
in Great Britain. What could be more different or more appealing?

Hamilton's poster helped to establish several of the dominant themes
in Pop art, which would not fully emerge as a movement until the early
sixties. First, the poster was largely composed of advertisements clipped

from popular magazines. In acknowledging the existence of such material, and then placing it in a collage, Hamilton suggested that the realm of mass media was not only worthy of inclusion in the highest ranks of Western culture, but also that traditional cultural distinctions – between the high and low, the elite and democratic, the unique and multiple – might be a vestige of an older, and now obsolete, aesthetic sensibility. His almost deadpan use of these ads was at once ironic and sincere, a duality that exists in most Pop art.

Hamilton was distinctly aware that the rapid changes in style and market appetites in the post-war years were carefully engineered through advertising. By so obviously using these advertisements in his collage, he called attention

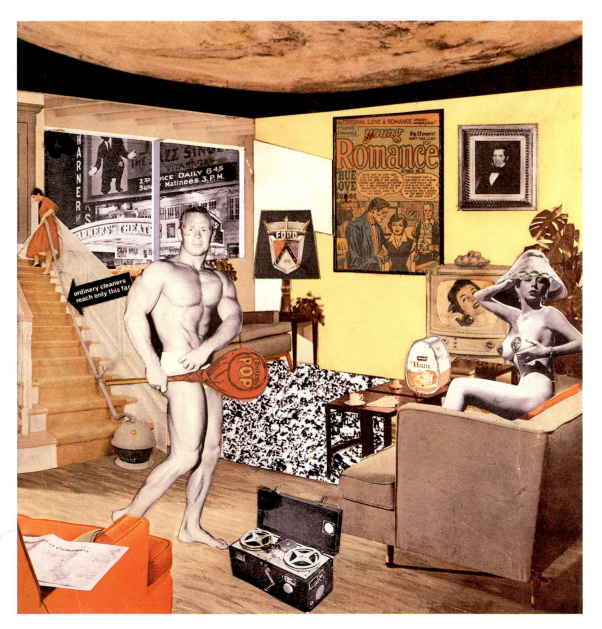

both to the tides of fashion and to the many audiences whose most immediate access to visual culture was not through museums and galleries, but through popular magazines. He took pre-existing images from their original contexts and transposed them into a new, carefully organised composition, without changing these images. Thus the ads retain something of their original identity – they hawk wares – and they now also function as commercial accessories in a believable, post-war, domestic interior.

This constant oscillation between advertising and art allowed Hamilton to remind his viewers that modern art frequently celebrated physical pleasure, and that it often took inspiration from previous artistic movements. Because his collage was so evidently about hedonism, both in itself and as it was deployed to direct viewer attention toward specific commercial products, Hamilton acknowledged that art might offer pleasures that were embodied and even vulgar. Importantly, the visual punch of *Just what is it?* owes as much to earlier modern art, such as Futurism and Dada, as it does to then contemporary commercial design.

The rich complexity of the poster was but a harbinger of an emergent artistic sensibility, one that significantly shaped the visual culture of Western art in the following decades. Just a year after finishing the collage, Hamilton enumerated many of the central tenets of this new sensibility in a letter to the architects and Independent Group members Alison and Peter Smithson. Like the collage *Just what is it?*, this new art should be 'popular, transient, expendable, low cost, mass produced, young, witty, sexy, gimmicky, glamorous, and big business' (Madoff 1997, pp.5–6).

The group to which Hamilton belonged, and for which he designed the collage, formed in the early fifties to promote new ways of thinking about modern art. Associated with the Institute of Contemporary Art in London, the Independent Group was composed of younger British artists and critics, mostly born in the early twenties, who were eager to challenge received ideas about modern art. Sensing that post-war culture would be democratic, inclusive and accessible, the Independent Group argued persuasively that modern art should follow suit. The group rejected the arcane difficulty of much previous modern art, as well as the belief that art and life were separate realms of experience with little to no points of contact.

A simple comparison between an example of Pop art and modernist art will help to make the point. In nearly the same year that Hamilton completed his collage, the Abstract Expressionist Mark Rothko produced *Light Red over Black* (fig.2). The contrast between the two works is as immediate as it is clear, and it helps us to see the difference between high modern – or modernist – art and the emergent sensibility of Pop. Whereas Hamilton's collage communicates its messages in the nearly transparent language of advertising, Rothko's painting maintains a resolute distinction between itself and consumer culture. The collage uses a figurative style and commercial iconography open to anyone familiar with popular magazines, while the painting is locked within a non-objective rhetoric knowable to those few individuals trained in the history and theory of modern painting dating to the years just before World War I. Where Hamilton wanted the instantaneous

2
Mark Rothko

Light Red over Black
1957

Oil on canvas
232.7 × 152.7
(91½ × 60)
Tate Gallery

recognition of slick design, the unambiguous communication of meaning
– BUY! – and the sensual, highly saturated colour typically found in
mass-circulation magazines, Rothko desired a slow, meditative experience
between work and beholder that was closer to the language of religious
devotion and inner revelation.

Hamilton's ideas were supported by the critical writings of Lawrence
Alloway, who first coined the term Pop, and Reyner Banham. Both critics
were members of the Independent Group. They provided historical
justification and explanation for the activities of several artists in the group,

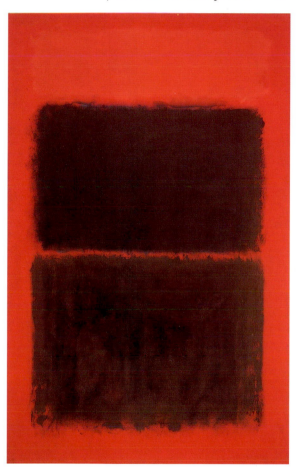

and thereby helped to lay the theoretical
foundations for Pop art. Alloway was
infatuated with popular culture, including
science fiction and Hollywood westerns, as
well as current theories of communication
and mass, commercial productivity. He
called for an 'aesthetics of plenty' in his
1959 essay 'The Long Front of Culture'
(Institute of Contemporary Art 1988,
pp.31–3). By paying attention to the influx
of magazines and movies from the United
States, as well as the ability of Detroit to
tailor automobile production to individual
tastes, he reasoned that a vitally new
area of visual culture was dramatically
changing the modern world while also
challenging traditional hierarchies of
artistic expression. Fine art needed to
respond to audience tastes or become
irrelevant. Banham, who would
subsequently publish the generative
study on design in the early twentieth
century – *Theory and Design in the First
Machine Age* (1960) – recognised that
technological change directly shaped
modern visual sensibility. His theory
called attention to an 'aesthetics of
expendability' based on the constant
need to stimulate market interest through stylistic change and planned
obsolescence. Alloway and Banham willingly stepped outside of the fine arts
to formulate their new aesthetic theories. Such border crossings revealed the
eclectic range of their interests, while simultaneously complementing their
desire to connect modern art with the fullest range of possibilities for visual
expression. In the mid-fifties Alloway described the transition from one realm
of culture to another as the 'fine art–popular art continuum' (Robbins 1990,
p.32). He thereby substituted a democratically inclusive definition of human
expression for a traditionally hierarchical and elitist division that separated
artefacts into fixed categories, some better than others.

The intellectual formation of the Independent Group was underpinned by a keen awareness of post-war austerity in Britain. After years of rationing, first during the war and later extended into the fifties (rationing did not end completely until 1954), one can imagine how exotic the products of American culture seemed to this younger generation of artists and critics. Constant change, endless variety, consumer choice, escapism and hedonism were just some of the promises of American advertising and mass publications. Thus we can recognise that in proposing a more comprehensive, anthropological definition for culture, the members of the Independent Group were responding to actual changes in their commercial environment.

Within six years of *This is Tomorrow*, Pop art would emerge as a major force in Western art on both sides of the Atlantic. And although it would not fully perpetuate the Independent Group's radical proposal to level the playing field of visual culture or sustain the critical engagement with new technology, Pop would continue the critique of modernist, that is non-objective, art as unnecessarily removed from life. Like their precursors in the Independent Group, the British Pop artists turned their attention to the environment of popular culture and mass media, perpetuating the belief that modern art must draw energy and insight from this previously neglected realm of culture. As Allen Jones later explained in a statement published in the Royal Academy's 1991 survey of Pop art, 'If your stimulations come from unartistic or untasteful sources and not from Bach, don't worry; if as a result you produce work, then it's justified' (Livingstone 1991, p.158).

In Britain, the importance of the Independent Group and its theory began to surface in art schools by the late fifties. One conduit was Richard Hamilton, who taught at the Royal College of Art from 1957 to 1966. Also teaching there were Eduardo Paolozzi and Richard Smith. Paolozzi's important collection of American advertisements helped the Independent Group form its ideas concerning mass media. He had also anticipated Richard Hamilton's poster in a series of magazine-derived, 'bunk' (or nonsense) collages from the late forties, including *It's a Psychological Fact Pleasure Helps Your Disposition* (fig.3). Smith's brightly coloured abstractions,

including *Panatella* (fig.4), frequently derived from commercial packaging, big-screen film, as well as contemporary American abstract painting, such as that produced by Mark Rothko. In 1956 and 1957 important Independent Group articles were published in the Royal College of Art journal *Ark*, edited by Roger Coleman.

Peter Blake was a student at the Royal College of Art in the mid-fifties, and his interest in popular culture paralleled that of the Independent Group. By the time he finished his studies in 1956, he was producing fully Pop paintings, as can be seen in *On the Balcony* (fig.5). Like *Just what is it?*, Blake's painting is overloaded with objects available to consumers: magazines and packaged food, cigarettes and postcards. Like Alloway, Blake suggests a continuum of cultural consumption large enough to embrace William

3
Eduardo Paolozzi

It's a Psychological Fact Pleasure Helps Your Disposition 1948

Collage mounted on card
36.3 × 24.4
(14⅛ × 9½)
Tate Gallery

4
Richard Smith

Panatella 1961

Oil on canvas
228.6 × 304.8
(90 × 120)
Tate Gallery

Shakespeare and Edouard Manet, as well as Elvis Presley and Marilyn Monroe, all of whom are acknowledged in the painting. The erasure of distinctions between fine art and mass consumption is paralleled by the style of painting and mode of pictorial organisation. In its near *trompe-l'oeil* clarity in reproducing postcards and magazine covers, the painting invokes the medium of photography. The impression that several objects are sitting on top of the canvas, rather than receding into illusionistic space, suggests the tackboards found in many of these artists' studios. Blake's painting also prefigured and licensed mod fashion of the mid-sixties, particularly the attention to stylish clothing and the prominent display of badges. He would further participate in the Pop culture of the following decade by designing album covers for bands such as The Beatles. Yet as much as Blake's painting

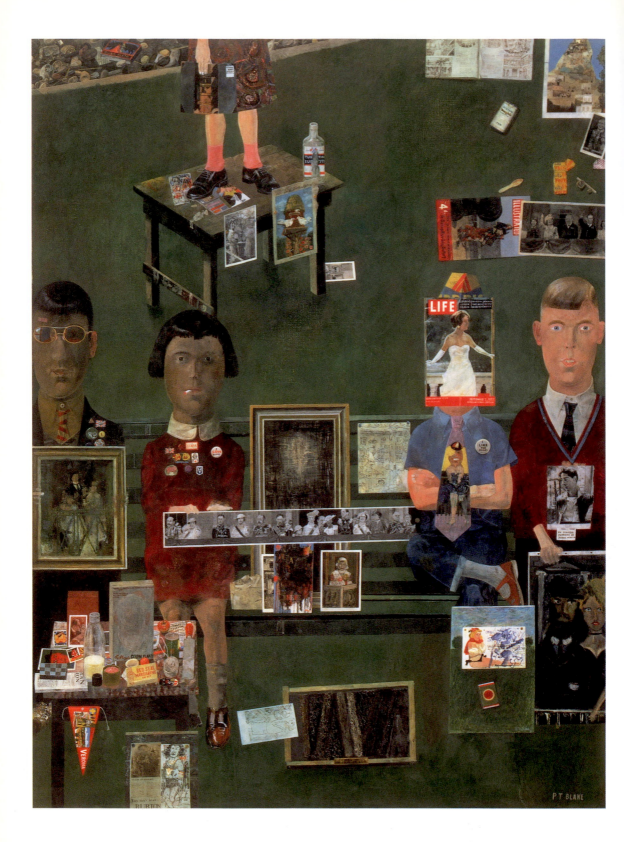

anticipated the styles of the sixties, it also emphasised the passing of time, which introduced a strongly nostalgic flavour to his art. The long, horizontal photograph of the Royal Family dates to his childhood in the thirties. Where Richard Hamilton often stressed the contemporaneity of his imagery, Blake mixed the topical with the dated, perhaps to suggest that everything ages.

A slightly younger generation of Pop artists followed Blake through the Royal College of Art, and received their first public notice at the *Young Contemporaries* exhibition at the Royal British Academy Galleries in 1961. Derek Boshier, Patrick Caulfield, David Hockney, Allen Jones, R.B. Kitaj, Peter Phillips and Norman Toynton were included in the show, with Hockney, Jones and Phillips quickly garnering attention. The diversity of style and subject matter found in the work of this generation demonstrates the heterogeneity of Pop in general. For instance, the expatriate American Kitaj was older than his fellow students, and generally rejected most popular culture. However, his interest in second-hand images appropriated from photographs and cinema helped to reinforce the directions already taken by his fellow students. The seriousness of his commitment to professional painting was also of great importance to the younger British artists around him, as several have attested. Jones and Phillips were perhaps closest to Peter Blake in mining popular culture for subject matter. Both developed a keen interest in splashy design and erotic innuendo, particularly Jones, whose misogynist rendition of the female nude would become the subject of feminist wrath a decade later. Hockney made gestural, figurative paintings informed by graffiti and a keen awareness of previous styles of art. His success at the *Young Contemporaries* exhibition was such that he became an instant celebrity and a central figure in British Pop, even though he disliked the label. Some of his paintings also revealed a different erotic sensibility, one not fully acknowledged until after the Stonewall Riots of 1969 ushered in the age of gay liberation. As will become clear in subsequent sections of this book, Pop art in Great Britain was as complex as that in the United States. Pop provided many artists with a working vocabulary that could be directed toward several ends, whether celebrating commercial culture or protesting American aggression in the Cold War.

The emergence of Pop in the United States differed from that in Great Britain. The artists trained at different schools, and worked in isolation from one another until late 1962 when several exhibitions – *Art 1963: A New Vocabulary*, organised by the Arts Council in Philadelphia, and *The New Realists*, held simultaneously at the Sidney Janis Gallery in New York – revealed several artists working with found materials from the commercial environment. Almost immediately Andy Warhol, Roy Lichtenstein, Claes Oldenburg, James Rosenquist and Tom Wesselmann were identified as the core Pop artists in the United States. They were united through a (very) loosely shared style of bright colour and simplified design, as well as sometimes commonly held subject matter. As with their British counterparts, whose work they did not know, the American Pop artists had no shared programme. They issued no group manifestos, and continued to work separately from one another after they were identified as the central

practitioners of the new sensibility. They certainly saw themselves as making a break, though not a complete one, with the heroic generation of the Abstract Expressionists. Many of them had tried to paint in a gestural style in the fifties, and found the results to be largely derivative of work already done by Willem de Kooning and Franz Kline. Though the American painters had no theoretical precursors, they did draw inspiration from the aesthetic stance of the composer John Cage, whose openness to the most insignificant, even apparently trivial, noises helped direct artistic attention to the minutiae of the surrounding world. His interest in and support of younger artists in New York also made him of direct importance.

With the development of Pop in the United States, it became clear that a willingness to look at and learn from the visual culture of the mass media and commercial environment constituted a significant trend in Western art, one that sustained artists on both sides of the Atlantic. Typically, American and British Pop are treated separately, which needlessly balkanises what was in fact a large, Western movement in the arts. And although it is beyond the scope of this short book, there was a Pop sensibility throughout Continental Europe in this period. One point of convergence between Pop in Great Britain and the United States is the element of class. Several of the most important practitioners, such as Paolozzi and Warhol, came from immigrant, working-class culture, and had little use for rigid hierarchies of form and subject matter. Another point of convergence is the interest in comic books, mass-circulation magazines and Hollywood cinema, which constituted a major component of the visual culture that nourished these artists in their formative years. A clear and obvious debt to photographic sources is evident in the work of many of these artists too. Strong formal design and vibrant colour, as well as an awareness of recent art in New York, binds both groups. Additionally, Pop was tied to moments of political change and optimism in Great Britain and the United States; both the Labour Party and the Kennedy Administration embraced the rhetoric of new technology in the early sixties. On both sides of the Atlantic, Pop seemed to be the one sensibility best attuned to defining this brief moment of change, and as the sixties played out their political history, Pop would eventually fade in its prominence.

However, over the course of a full decade, Pop was one of the central movements in British and American art, establishing several individuals as artists of the first rank, affecting directly the course of later art throughout the world, and reconfiguring our understanding of twentieth-century culture. Pop eschewed the rigid, either/or strictures in some manifestations of modernism in favour of an art that was both visual and verbal, figurative and abstract, created and appropriated, hand-crafted and mass-produced, ironic and sincere. It was as complex and dynamic as the moment and artists who gave it life.

PEDIGREE

It is deceptive to suggest that Pop art was fully opposed to previous modern or modernist art, or that it was designed to be understandable to anyone who happened to see it. It was a thoroughly learned movement with a keen awareness of its historical precedents. Furthermore, it is no coincidence that it developed in the years that witnessed the institutionalisation of modernism. Prominent museums, such as the Tate Gallery in London and the Museum of Modern Art in New York, important art schools, including the Carnegie Institute in Pittsburgh where Andy Warhol trained in the late forties and the Royal College of Art, as well as several influential art magazines – perhaps most importantly *Artnews* – provided constant access to vanguard art of the preceding century.

Yet before we examine Pop's debts to previous art, we must at least acknowledge one of the historical ironies of a movement noted for its interest in irony. The term 'popular' initially signified the mass-produced and accessible, at least in the minds of Lawrence Alloway and the Independent Group. However, in subsequent years Pop art, which drew some of its inspiration from mass culture, came to encourage and even demand a high degree of art historical knowledge from its viewers.

Pop drew several of its ideas and attitudes from early twentieth-century art movements. The appropriation of two-dimensional, printed materials from the commercial environment can be traced to the Cubist collages – compositions of two-dimensional materials glued onto a flat surface – that Georges Braque and Pablo Picasso produced in Paris between 1912 and 1914.

Their interest in popular culture, especially the posters, signs, newspapers and food associated with café life, was echoed fifty years later in many Pop still lifes, especially those by Tom Wesselmann. Before the advent of World War I, the Futurists in Italy celebrated speed and modern technology, particularly that of the automobile, as a uniquely modern experience. The Independent Group directly benefited from the example of Futurism, largely due to Reyner Banham's interest in the movement. By the late fifties, Richard Hamilton would make the marketing of automobiles a major theme in his art, as is evident in *Hers is a lush situation* (fig.6).

More important for the development of Pop, however, were Dada and Surrealism. The first movement dated to the years of World War I and often embraced nihilism and an anti-art aesthetic in protest against the civilisation that gave birth to the war. The second movement built on the first, but wished to revolutionise human consciousness by acknowledging the fundamental reality of unconscious drives. Historical attention made these movements available to a younger generation of artists after World War II. Early in the fifties, for instance, the Abstract Expressionist painter Robert Motherwell released an influential anthology of essays by the Dada poets and painters. Surrealist art was avidly collected in the post-war years, and was perceived as a still vital source of ideas by younger artists. Both movements must be treated separately so that we can discern their importance for Pop.

In a 1956 essay on Dada, Lawrence Alloway summarised the impact of this movement on the Independent Group by stressing the 'skeptical and permissive' attitude of the Dada artists in regard to fine art (Robbins 1990, p.164). In a clever slight of hand that mimicked the Dada interest in word play, he further reasoned that the movement spelled backward was 'AD/AD', an insightful pun that conjoined the realm of advertising with that of ever increasing consumption. Dada's irreverent and iconoclastic attitude, as well as its willingness to accept almost anything into the realm of art, certainly aided in the development of Pop. Dada also popularised several techniques that were later embraced by Pop artists. The found object was something found or selected by the artist, and then exhibited without alteration. When such objects were manufactured or mass-produced, they were labelled ready-mades. Both kinds of object helped the Dadaists to reject the idea that art was only a form of handicraft. Perhaps the most infamous example was Duchamp's *Fountain*, a porcelain urinal he signed and submitted to the Society of Independent Artists exhibition in New York in 1917. Another favoured technique was collage, which in the twenties was extended into its photographic partner, montage. To the Cubist pantheon of café artefacts, the Dada artists added urban refuse, as well as imagery culled from trade magazines and industrial manuals.

Surrealism had deep institutional support in London and New York, at the Institute of Contemporary Art and the Museum of Modern Art respectively. It also survived World War II, and therefore provided a bridge, no matter how tenuous or damaged, to the heroic, pre-war world of Continental modernism. Like Dada, Surrealism utilised chance encounter

6
Richard Hamilton

Hers is a lush situation
1957

Oil, cellulose, metal foil
and collage on wood
81 × 122
(31¾ × 48)
Tate Gallery

to produce startling new meanings, while also perpetuating the importance of the found object, or *objet trouvé*, as a significant element in artistic production. Displacement, or the removal of objects and images from their original environments, was a favoured tactic to induce surprise. Combined with these techniques was a strong interest in fantasy and desire, both of which feature strongly in the Pop infatuation with consumerism.

The conduit through which Dada and Surrealism passed into the Independent Group and later British Pop was Eduardo Paolozzi, though I should hasten to add that Pop on both sides of the Atlantic did not aspire to a critique of bourgeois society as did these previous movements. In Paris in 1947–8, Paolozzi encountered Max Ernst's collages from the early twenties

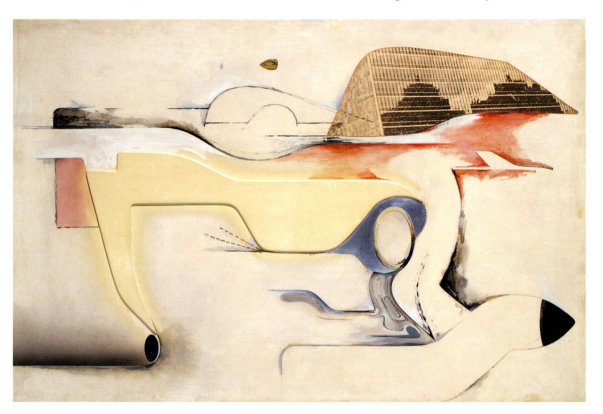

and Marcel Duchamp's studio with American magazine pages covering the walls. Paolozzi also embraced the Surrealist concept of the *objet trouvé*. With little to no manipulation of these source materials, Paolozzi, who considered himself closer to Surrealism than Pop, forced viewer recognition of previously overlooked materials (Livingstone 1991, p.160). Richard Hamilton's infatuation with technology and eroticism was directly indebted to Marcel Duchamp's work in 1910–20, perhaps most notably *The Bride Stripped Bare by Her Bachelors, Even*, also known as *The Large Glass* (1915–23, Arensberg Collection, Philadelphia Museum of Art). In the sixties, Hamilton would produce a facsimile of the assemblage, now in the collection of the Tate Gallery, in homage to the older, French artist.

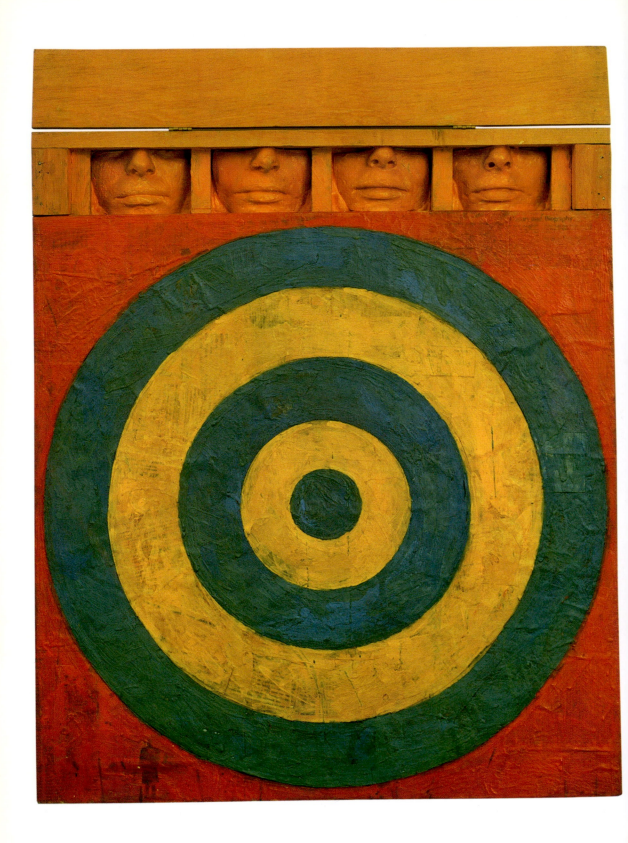

Dada and Surrealism made their way into American Pop through the work of Jasper Johns and Robert Rauschenberg in the fifties. Johns focused on 'things which are seen and not looked at', as he told the curator Walter Hopps in an interview in 1965 (Livingstone 1991, p.48). These things often came in the form of simple shapes such as circles (targets) and rectangles (flags, numbers and letters), as is evident in *Target with Four Faces* of 1955 (fig.7). He painted these shapes in a gestural, though nonetheless representational style, that simultaneously emphasised the painted and objective, or created and factual, qualities of the resulting work. An illusion and a thing, Johns's

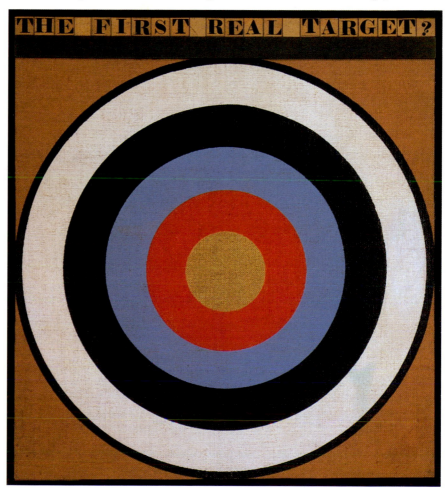

7
Jasper Johns

Target with Four Faces
1955

Encaustic on
newspaper and
collage on canvas
with plaster casts
85.3 × 66 × 7.6
(33½ × 26 × 3)
Museum of Modern Art,
New York

8
Peter Blake

*The First Real
Target?* 1961

Oil on canvas
53.7 × 49.5
(21¼ × 19½)
Tate Gallery

9
Andy Warhol

*200 Campbell's Soup
Cans* 1962

Synthetic polymer paint
and silkscreen ink on
canvas
182.9 × 254
(72 × 100)
Private Collection
(over page)

paintings helped pave the way for Pop, as acknowledged directly by Peter Blake in his painting, *The First Real Target?* (fig.8). Andy Warhol's emphasis on brand-name products, abundantly evident in the silkscreen *200 Campbell's Soup Cans* (fig.9), implicitly derives from Johns's centralised, emblematic, flat imagery.

Rauschenberg, meanwhile, transformed collage into a series of 'combine' paintings that significantly blurred the distinctions between painting and sculpture, collage and assemblage (a three-dimensional collage sometimes to be viewed in the round). His famous pronouncement that he wanted to work

in the 'gap' between art and life, first published in the *Sixteen Americans* catalogue at the Museum of Modern Art in 1959, helped foster a both/and possibility for post-war art that stood at odds with the either/or mentality of modernist painting. In particular, Rauschenberg's use of found materials, including comics, newspapers, pieces of decorative woodwork and even a mirror, all evident in *Collection* of 1954 (fig.10), made such sources legitimate for the Pop artists who followed in his wake.

The assemblage aesthetic, chronicled in *The Art of Assemblage* exhibition at the Museum of Modern Art in 1961, was an important precursor and parallel to Pop. Many of the artists included in the exhibition worked on the periphery of Pop, and were sometimes shown with the Pop artists

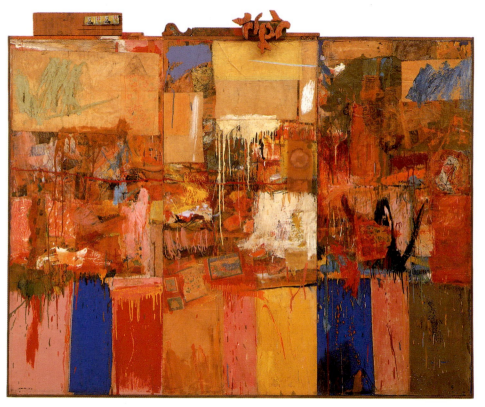

10
Robert Rauschenberg
Collection 1954

Oil, paper, fabric and metal on wood
203.2 × 243.8 × 8.9
(80 × 96 × 3½)
San Francisco Museum of Modern Art

11
Jim Dine

Five Feet of Colorful Tools 1962

Oil on unprimed canvas surmounted by board with 32 painted tools on hooks
141.2 × 152.9 × 11
(55½ × 60¼ × 4¼)
Museum of Modern Art, New York

12
Claes Oldenburg

Soft Drainpipe – Blue (Cool) Version 1967

Acrylic on canvas and steel
259.1 × 187.6 × 35.6
(102 × 73¾ × 14)
Tate Gallery

themselves. These artists ranged from the Americans Bruce Conner and Edward Kienholz, to the French Nouveau Réalists Arman and Niki de Saint-Phalle, and the Italians Enrico Baj and Mimmo Rotella. Though the assemblage artists remained closer to the roots of Pop as found in Dada and Surrealism, they nonetheless remind us that Pop was neither a singular nor isolated movement, but in fact represented one of several possibilities in the early sixties for circumventing a modernist sensibility predicated on separating art from life. What differentiates Pop from assemblage is the former's insistence on simple, clear-cut design derived from advertising and mass communications without the latter's emphasis on accident, age and distress, though these distinctions were not necessarily

clear at the time. In general, Pop tended to privilege two-dimensional media such as print making and painting, while assemblage remained closer to the three-dimensional nature of sculpture.

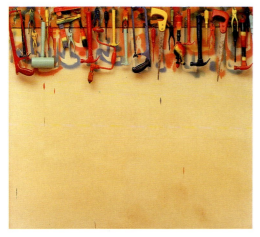

Throughout the sixties, several Pop artists continued Dada and Surrealist practices. Jim Dine's presentation of tools across the top of the canvas in *Five Feet of Colorful Tools* (fig.11) directly echoes Duchamp's use of similar ready-mades in 1910–20. Claes Oldenburg's confounding of expectations – making small objects unusually large, or hard materials soft – harks back to Salvador Dali's infatuation with dramatic shifts in scale and fondness for softness in the thirties. *Soft Drainpipe – Blue (Cool) Version* (fig.12), for instance, takes on the outlines and materiality of a used prophylactic, which in turn changes one's perception of a common drainpipe. This belief in transforming vision, to force awareness of the unseen or overseen, also finds resonance in Surrealism.

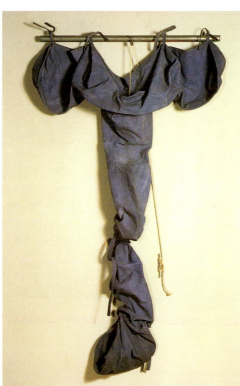

Among the American Pop artists, Oldenburg most helped to perpetuate the radical promise of Surrealism by using displacement to engender a new awareness of one's surroundings. In 1961, he published a manifesto for a new art that boldly began, 'I am for an art that is political – erotical – mystical, that does something other than sit on its ass in a museum' (Madoff 1997, p.213). It was a call to return art to the complexities of life by suggesting that art could take its form and inspiration from just about anything, from fast food and neon signs to clothing and urban decay. Surrealism helped him to see the poetic possibilities of mundane objects, such as drainpipes, and it therefore provided an important source of ideas for Pop in general.

Both Dada and Surrealism were embraced in the fifties because those movements helped younger American artists get around the imposing example of Abstract Expressionism. Emphasis on all-over surface design, flatness of the picture plane, large size and scale, and even occasional references to popular culture were ideas traceable to this important movement. Willem de Kooning, Jackson Pollock and Franz Kline were treated as major artists whose painting in the preceding decade was considered canonical. However, they were also seen as part of an earlier moment, one fading rapidly from view by the late fifties. Where the

Abstract Expressionists often invoked nature as a metaphor for the creative process, the Pop artists identified with the commercial environment of cities and the carefully designed look of industrial products. By 1965, Roy Lichtenstein could celebrate and dismiss gestural abstraction in a series of parodies, including *Brushstroke* (fig.13), that treated abstract-expressionist painting as a giant, mass-produced, cartoon image, instead of the trace of individual engagement with one's materials it was intended to be. In this regard, Johns and Rauschenberg must be acknowledged as giving the Pop artists a useful updating of Dada and Surrealism, because they demonstrated

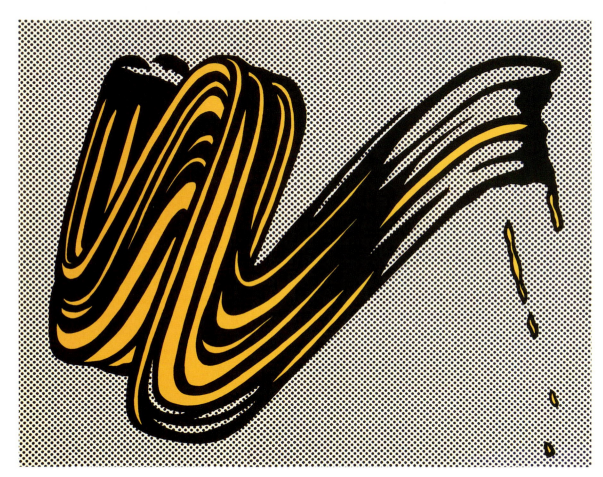

how these previous movements, with their interest in found objects, could be utilised to critique the romantic individualism of Abstract Expressionism, and modernist painting in general.

For all of its historical indebtedness, though, Pop was – and remains – a movement inextricably intertwined with the sixties. Like Minimalism and Post-painterly Abstraction, Pop was simple, hard-edged, flat, anti-gestural and pre-meditated in its style. In its pictorial organisation, Lichtenstein's picture has more in common with contemporaneous abstract paintings by Al Held, Ellsworth Kelly and Frank Stella, than with work by Pollock. A similar aesthetic also marks Pop sculpture, which shares with Minimalism the

emphasis on simple, easily graspable shapes. Andy Warhol's *Brillo Box* of 1964 (fig.14) is strikingly similar to the boxes of Robert Morris, Donald Judd, and Walter De Maria. In summation, we can think of Pop, like other movements in the sixties, as growing from the ferment of the fifties, developing some ideas broached in that decade, while also arguing for a new artistic sensibility.

This sensibility, even though heterogeneous, can be summarised through attention to form and subject matter, as well as process. The form often includes saturated colours, lack of painterly brush stroke, simple shapes, crisp contour and outlines, and suppression of deep space. The subject matter frequently derives from pre-existent sources originally manufactured for mass consumption. Among these sources are newspaper photographs, colour advertisements, commercial signs, comic books and movies. The process by which the art is made is sometimes abbreviated in the sense that the artists forgo the traditional preparation of sketches, studies, underpainting and finishing, for a direct transfer of imagery through collage and silkscreen. Again, I should add that the Pop artists did not originate these traits and processes. Rather, they took them in hand because they best allowed the artists to achieve a new look in painting.

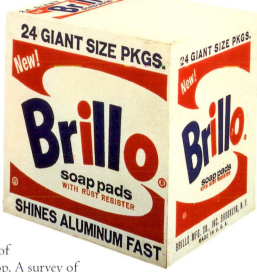

Pedigree implies a line of descent from identifiable origins, and we should not be too surprised to find that Pop betrays some of the biases evident in the twentieth-century movements from which it drew inspiration. If, as is now commonly argued, modernism was largely a masculine enterprise with men describing the world from their point of view, we should expect no less from Pop. A survey of Pop artists on both sides of the Atlantic will turn up no major women within the movement. In the United States, the sculptor Marisol Escobar showed with the men; however, her emphasis on constructing tableaux kept her closer to assemblage than advertising. In Britain, Pauline Boty mined similar terrain as Allen Jones and Peter Phillips. Only recently has she begun to receive critical attention. One way of explaining the gender bias in Pop is to focus on the age and interests of its practitioners. The concerns of the members – technology, science fiction, automobiles, advertising, pin-ups – were gender-specific in the post-war years. In an interview from 1982, Peter Phillips claimed that Pop was a movement initiated by young men who celebrated their most immediate interests, including pictures of women (Livingstone 1991, p.160). Such bias is to be expected from a movement that desired to partake of the rich complexities of the post-war world, and as we shall see in subsequent sections, Pop delved into many of the most controversial subjects confronting its historical moment.

<div>

13
Roy Lichtenstein

Brushstroke 1965

Screenprint on paper
56.5 × 72.4
(22⅛ × 28½)
Tate Gallery

14
Andy Warhol

Brillo Box 1964

Synthetic polymer and silkscreen on wood
43.2 × 43.2 × 35.6
(17 × 17 × 14)
Private Collection

</div>

3

Production and Consumption

In his 1961 essay, 'For the Finest Art Try Pop,' Richard Hamilton claimed that 'the artist in twentieth century urban life is inevitably a consumer of mass culture and potentially a contributor to it' (Harrison and Wood 1992, p.727). His insight was neither cynical nor apologetic. Rather, it indicated a growing awareness that the post-war world was recognisably different from those earlier moments in the century that witnessed the development of modern art. Several years later Andy Warhol blithely confessed in *The Philosophy of Andy Warhol (From A to B and Back Again)* that, 'Being good in business is the most fascinating kind of art. . . . Making money is art and working is art and good business is the best art' (Mamiya 1992, p.132). This startling confession came from the man who called his studio the Factory. Instead of thinking of artists as a breed apart or a sacred brotherhood alienated from their culture, Hamilton and Warhol insisted that they were as much a part of contemporary culture as any successful businessman. In fact, many of the Pop artists behaved like aggressive entrepreneurs in acknowledging and capitalising on the expanding markets and audiences of the post-war years.

Hamilton's and Warhol's statements suggest that the Pop artists were both familiar with and at ease within the world of post-war production and consumption. While the subject matter of their art directly acknowledged the rapid spread of commercial goods available in increasing quantities throughout the decade of the fifties, the style of such art embraced the splashy design of advertising. A good example is Hamilton's collage painting

15
Richard Hamilton
$he 1958–61
Oil, cellulose paint and collage on wood
121.9 × 81.3 (48 × 32)
Tate Gallery

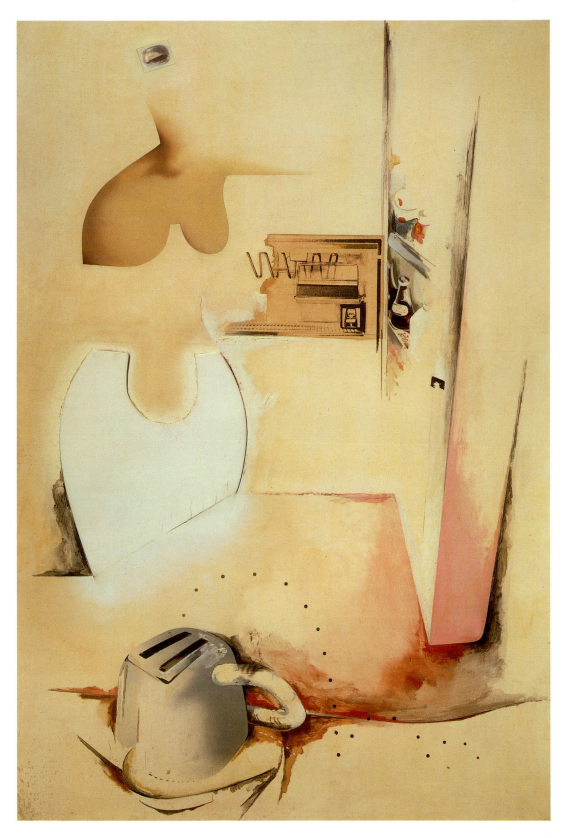

She (fig.15), which joins a toaster and vacuum cleaner hose with an open refrigerator door that reveals a bottle of Pepsi-Cola and other canned goods. In turn, Hamilton's production of fine art, like that of the other Pop artists, seemed to license the consumption of many commodities, including art itself. Pop art's status as product is inseparable from its call for consumption. In fact, the two identities are almost always evident in the art itself and in the studio practice of the artists. This insight concerning Pop's dual nature can be understood by reviewing the moment of the fifties and early sixties when economists, politicians, critics and artists explained, debated and celebrated this new world of commodity abundance.

With a rising population and increasing standard of living throughout the fifties, many Americans felt that the austerities of the Depression were things

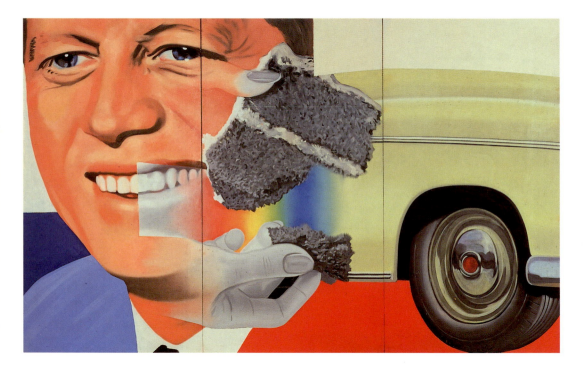

of the past. Noting that widespread wealth like that found in the post-war years was unprecedented historically, the economist John Kenneth Galbraith coined the term 'affluent society' in 1958 to describe the current situation of financial comfort. Indeed it seemed that the American Dream was no longer defined by political freedom, but instead was measured by the number of commodities citizens could acquire. Americans were consuming popular magazines (such as *Life* and *Time*), cinema and television, pop music and rock 'n' roll, automobiles and domestic appliances in steadily increasing numbers. They were encouraged to spend by a vast advertising sector that deliberately interpreted consumption as a measure of one's financial success and psychological well-being.

In the realms of international and domestic politics, such abundance was readily identified with the promise of America, and was disseminated through

the relatively new medium of television. In his famous 1959 'kitchen debate' with Soviet Premier Nikita Krushchev, Vice-President Richard Nixon argued that the distinction between Capitalism and Communism was best made through consumer choice. At a critical moment in a live broadcast from Moscow, the Vice-President pointed to the variety of washing machines available to American consumers as an index of their freedom. The following year Nixon would be defeated in the presidential election by the Democratic candidate, John F. Kennedy, whose media-conscious campaign dramatically transformed American politics. A growing emphasis on marketing, image recognition, consumerism and packaging, all examined and employed by the Pop artists, seemed to summarise the appeal of the new president, as is

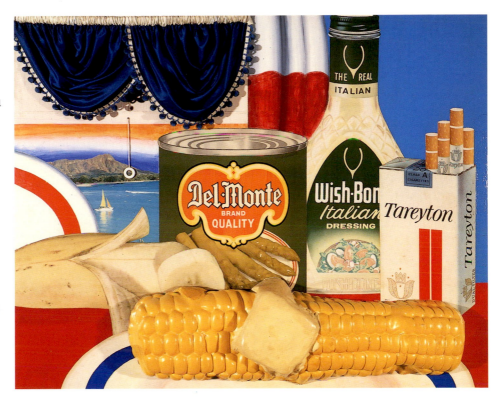

16
James Rosenquist

President Elect 1960–1

Oil on masonite
226.1 × 366.3
(89 × 144)
Musée national d'art
moderne
Centre Georges
Pompidou, Paris

17
Tom Wesselmann

Still Life No. 24 1962

Acrylic polymer on
board, fabric curtain
122 × 152.1 × 20
(48 × 60 × 8)
Nelson-Atkins Museum
of Art, Kansas City,
Missouri

evident in a painting by James Rosenquist. *President Elect* of 1960–1 (fig.16) intertwines a famous poster of the highly photogenic Kennedy with fragments of magazine advertisements for instant cake and a Chevrolet. At the dawn of the new decade, abundance was the official promise of America.

Although this desire to consume presented producers and politicians with an economic boon, it troubled several critics throughout the decade of the fifties. Some American intellectuals noted with increasing alarm that new mass audiences were gradually reshaping the national culture. Clement Greenberg and Dwight Macdonald saw a general decline in artistic standards as more and more people considered the fine arts one of the necessities of life, especially when available at reasonable rates. As early as 1939 Greenberg warned about the spread of kitsch, or mass-produced objects of inferior

quality, into the arts. Some two decades later Macdonald lamented the influx of 'masscult' and 'midcult' culture – the former intended for those classes who lacked the requisite training to appreciate the refined products of Western culture, the latter substituting for avant-garde art without its insights or difficulty. What Americans wanted, apparently, was not what cultural critics thought was best for them, or for the fine arts.

When seen from across the Atlantic, however, this new world of abundance appeared highly exotic because it contrasted so dramatically with the British post-war economy, although the discrepancy between British

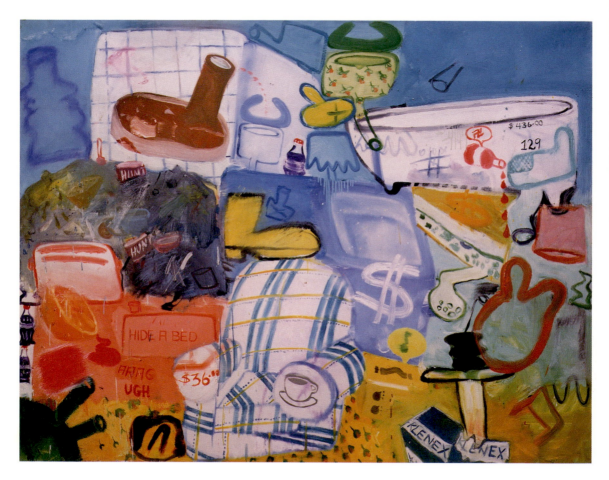

and American prosperity would lessen through the sixties. The appeal of this world was summarised by Eduardo Paolozzi in a statement published for an Independent Group retrospective in 1990. 'The American magazine represented a catalogue of an exotic society,' he recalled, 'bountiful and generous, where the event of selling tinned pears was transformed into multi-coloured dreams, where sensuality and virility combined to form, in our view, an art form more subtle and fulfilling than the orthodox choice of either the Tate Gallery or the Royal Academy' (Robbins 1990, p.192).

If this land of 'multi-coloured dreams' seemed exotic and seductive, it also provided incentive for questioning the look and content of modern art.

In a famous essay published in 1958, 'The Arts and Mass Media', Lawrence Alloway argued against critics such as Greenberg by suggesting that it was time for the fine arts to join the rest of human culture instead of remaining aloof (Madoff 1997, pp.7–9). After all, he reasoned, movies could be as nuanced and subtle in their attention to human motivation as traditional literature. According to Alloway, the mass culture exported from the United States, which constituted a significant part of its growing economy, should transform art.

Regardless of where and how these new commodities were encountered, they provided the material for numerous Pop paintings. The wealth of commercial products crowding Richard Hamilton's collage *Just what is it?* clearly celebrated the age of bounty, and without the moralising overtones against gluttony found in traditional still-life painting. Similarly, several Americans resorted to visual overload to capture post-war prosperity. Tom Wesselmann's still lifes, like those of Peter Saul and Wayne Thiebaud, used saturated colour, congested space and commercial products to mimic the jarring visual language of advertising, while also elevating throw-away artefacts to the status of fine art (figs.17–19). For several of these painters processed food was a sign of American affluence in the sixties, and such products certainly resonated with those individuals who lived through the Depression. In the hands of Andy Warhol, boxes of Kellogg's Corn Flakes, Del Monte peaches and Campbell's tomato juice

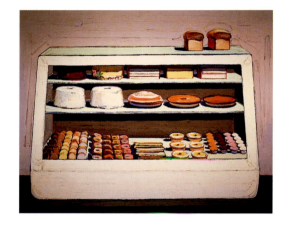

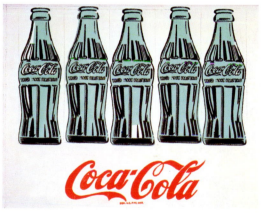

signified abundance on a scale inconceivable before the war, as did his silk screens of Campbell's soup and Coca-Cola (fig.20).

This was a strangely doubled world of objects for sale. The things represented within the paintings were available to people of most classes, while the paintings themselves, which proved to be highly marketable as art commodities, were likewise available, especially when reproduced as prints, posters, and postcards. In this fashion the Pop artists could use the market success of certain widely known products to help sell their own work. Thus one way to succeed in business was to sell customers the image of their own tastes repackaged and sanctified by the aura of fine art.

Other highly popular contemporary commodities chronicled by the Pop artists included automobiles and the vast new support network that came with them. Hamilton and Rosenquist were quick to acknowledge the libidinal appeal of the automobile. In *Hommage à Chrysler Corporation* of 1957 (fig.21), Hamilton noted the formal parallels between automobile and female form. Inspired by Reyner Banham's writing about contemporary automotive design and actual advertisements for Chrysler, General Motors and Pontiac cars, the painting worked to engender automobiles as feminine. Celebrating the possession and control of an automobile as a rite of masculine passage was a common theme in the fine-art–popular-art continuum. Earlier in the century Filippo Tommaso Marinetti's Futurist Manifesto of 1909 featured an infamous car trip through the streets of Milan. In post-war pop and rock lyrics, driving a car was often equated with sexual initiation and prowess. The

title of Rosenquist's *I Love You with My Ford* (fig.22) simultaneously suggested that Americans made love with and in their cars. The imagery neatly conjoined the staged fantasy of Hollywood romance (perhaps encountered at a drive-in theatre), with the stylised grillework of a 1950 Ford, and the saturated, slightly nauseating colour of canned spaghetti. All, of course, were readily available to consumers.

The allure of the open road, of adventure and new beginnings, or at least of mobility – whether physical or economic – tied the Pop infatuation with cars to the post-war promise of comfort and the American Dream of economic rebirth. For West-Coast artist Ed Ruscha, the Standard stations dotting the road were as sleek and clean as the vehicles they serviced (fig.23). For Allan D'Arcangelo, the road itself was the domain of signs and wonders often promising creature comforts. The road signs in *U.S. Highway 1* (fig.24) offered direction and assistance to motorists enjoying the benefits of an expanding economy. Through the eyes of the Pop artists, we can see that automobiles were worldly signs of success and affluence that could transport consumers to a world of commodities for the price of a tank of gas.

The transparent language of advertising, which suggested a simple trade of money for gratification, was familiar to most Western individuals in the fifties and sixties. The American Pop artists knew this world quite well, as several of them had experience in design and advertising. In the fifties Jasper Johns and Robert Rauschenberg sometimes designed window displays for Tiffany and Company, as did Warhol and Rosenquist for the New York department store

21
Richard Hamilton

Hommage à Chrysler Corporation 1957

Oil, collage and metal foil on panel
122 × 81
(48 × 32)
Tate Gallery

22
James Rosenquist

I Love You with My Ford 1961

Oil on canvas
86.4 × 91.4
(34 × 36)
Moderna Museet, Stockholm

Bonwit Teller. Rosenquist developed his interest in large-scale and popular imagery while supporting himself as a bill-board painter. Occasionally, Roy Lichtenstein worked in commercial design and window display in the fifties, and in a 1963 interview with the critic Gene Swenson suggested that Pop was a function of capitalism and industrialism (Madoff 1997, p.109). Warhol, who left a very lucrative and successful career in commercial advertising to make Pop art, was unapologetic in his commitment to the market. Like a canny corporate investor, he diversified his investment portfolio by the late sixties

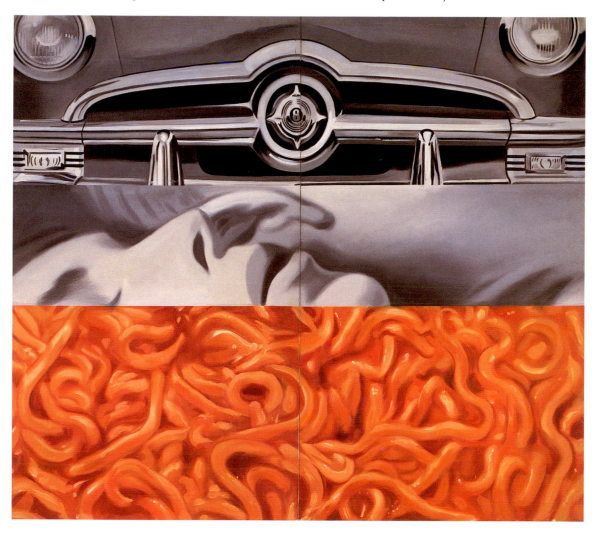

to include music, film, fashion and publishing, with the Warhol name itself serving as copyright.

Additionally, some of the Pop artists embraced commercial techniques in the act of making their work. In many of his images, including *Brushstroke* of 1965 (fig.13), Roy Lichtenstein mimicked the look of cheap mass-produced images through the use of Benday dots, which in cartoons and advertisements are used to produce half-tones. Warhol, who understood the market better than any of the other Pop artists, virtually abandoned traditional easel

painting by 1962 to focus on silkscreen. The advantage over painting came
in producing multiple copies of single images, so that more people could
purchase the same, or nearly the same, work. When combined with a loyal, if
underpaid staff in the Factory, the Warhol 'machine', as he claimed he wanted
to be in a 1963 interview with Gene Swenson, was able to mass-produce art,
thereby guaranteeing him a larger share of the art market (Madoff 1997,
p.104). Warhol left behind an estate valued at nearly $100 million when he
died in 1987, and was, by some estimates, nearly as recognisable worldwide
as Pablo Picasso (Mamiya 1992, p.1).

For many critics, Pop art's proximity to the market, indeed its collusion
with and even exploitation of it, presented several problems in assessment
and interpretation. For example, Claes Oldenburg introduced his earliest
Pop sculpture to New Yorkers in a performance entitled *The Store* staged in
December 1961. In an actual storefront in lower Manhattan, he sold plaster

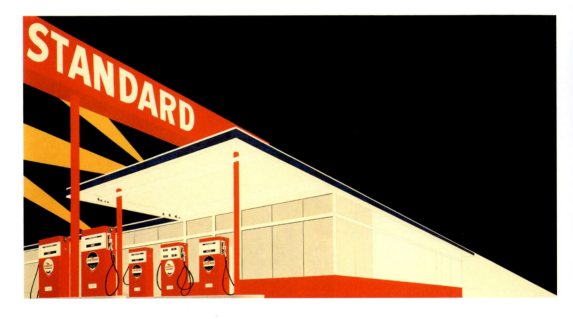

food and clothing, like *Counter and Plates with Potato and Ham* (fig.25), thereby
expanding his role as artist or producer to include that of salesman too.
In front of these objects, the critic Sidney Tillim did not know whether to
evaluate individual items according to their aesthetic interest or market value.
Was he a critic or a consumer in this liminal space, he wondered.
(Madoff 1997, pp.27–8).

Such questioning was not isolated, and it certainly was to the point. Was
Pop art simply a better, more 'artistic' form of advertising, or did it try to
distance itself from its sources of inspiration to comment on the world of
mass communications and consumerism? There was no clear answer to this
question. In a 1963 essay entitled 'The Flaccid Art', Peter Selz dismissed
Pop as little more than an extension of Madison Avenue, which indicated
just how little difference some critics saw between the movement and outright
advertising (Madoff 1997, p.86). Because Warhol appropriated the registered

trade name and characteristic text of Coca-Cola, and then silkscreened it on canvas, there was, in fact, no real distance between the art and its source. One could interpret his act as analogous to the Dada use of the ready-made, or read his silkscreen as a commentary on similarities between the art objects and mass-produced objects. However, the conclusions one reached would be one's own because the art itself did not always dictate how it should be interpreted.

Such apparent lack of commitment, which some critics defined as 'cool', was central to Pop and its take on the world. In his 1962 essay 'After Abstract Expressionism', Clement Greenberg complained that Pop was too close to safe, meaning bourgeois, taste to be of much interest (Madoff 1997, p.13).

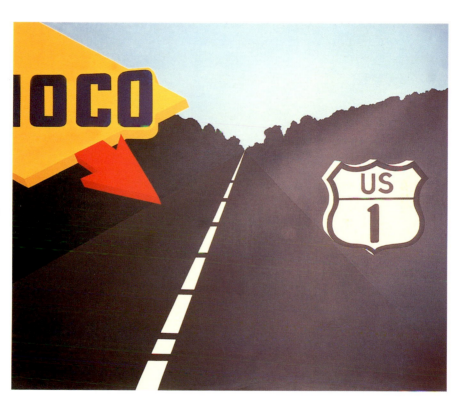

23
Ed Ruscha

Standard Station,
Amarillo, Texas 1963

Oil on canvas
165.1 × 315
(65 × 124)
Hood Museum of Art,
Dartmouth College,
Hanover, New Hampshire

24
Allan D'Arcangelo

U.S. Highway 1 1963

Acrylic on canvas
177.8 × 205.7
(70 × 81)
Estate of the artist

At a symposium on Pop art hosted by the Museum of Modern Art in 1963, Leo Steinberg admitted that the movement's rejection of traditional ideas concerning the separation of vanguard art from bourgeois culture presented problems for critics. Helpfully, he described the artists as neither radicals nor non-conformists, but rather as 'non-dissenters' – individuals who did not wish to attack bourgeois ideas about art and culture, except the worn-out idea that all modern art was supposed to be difficult at first (Madoff 1997, p.80). At the same symposium Hilton Kramer lamented that Pop's dubious achievement was to 'reconcile us to a world of commodities, banalities, and vulgarities' (Madoff 1997, p.69). That same year Barbara Rose drew a distinction between Pop and its debt to Dada in the essay 'Dada, Then and Now'. Rejecting the Neo-Dada tag that was pinned to Pop

activities in the late fifties, she reasoned that the new movement was too accepting of art and too little interested in protest to have much in common with the radical tenets of its historical precursor (Madoff 1997, pp.57–64). When measured against the passionate work of the preceding generation of Abstract Expressionists, Pop's passive detachment looked positively suspect, even if it was an aesthetic stance shared by other post-war movements.

Critical dismissal and attack were, in some senses, beside the point. Whether the critics liked it or not, Pop proved to be a commercial and popular success. Early shows by the artists in the United States immediately attracted collectors who wanted to share in the excitement generated by a new, splashy art movement. Several prominent dealers in New York, most notably Sidney Janis and Leo Castelli, also contributed to the escalating presence of Pop by aggressively promoting the art as the latest thing. By 1964, American Pop was shown officially at the Venice Biennale, with Robert Rauschenberg winning the international grand prize for painting – the first time the award

25
Claes Oldenburg

Counter and Plates with Potato and Ham 1961

Painted plaster
11.7 × 107.3 × 57.8
(4½ × 42¼ × 22¾)
Tate Gallery

went to an American. Through the rest of the decade, Pop was a staple at international exhibitions. Combined with this international recognisability was a steadily escalating monetary value for Pop, especially for the work of Warhol and Lichtenstein. By the early eighties, they were grossing more than a million dollars a year (Mamiya 1992, p.13). Perhaps the final measure of acceptance came in the middle of the sixties, when magazines and commercial designers began to emulate the look of Pop, thereby completing the circuit of inspiration that initially led from magazines to paintings.

The Pop artists became men of the world by turning to consumer culture as the subject matter for their work. Theirs was a sound business decision because the controversy they courted increased their visibility, which in turn gave them the (free) advertising that helped to enhance their reputations. Promoted by aggressive dealers, as well as noted, and sometimes nouveau riches, collectors, the Pop artists quickly garnered the fame and fortune accorded the celebrities they sometimes depicted.

FAME

Andy Warhol's notorious prediction that in the future everyone would be famous for fifteen minutes was something more than an offhand remark that made for good copy (McShine 1989, p.460). The prognostication, both democratic in its sentiments and terrifying in its implications, was based on two themes of direct interest to the Pop artists: mass media and celebrity. The first was part of the mid-century boom in mass communications such as television and popular magazines that celebrated and spread American abundance. The second, logically following the first, recognised that fame was contingent on broad public recognition through media exposure. By the time Warhol and other Pop artists directed their attention to contemporary fame, they had a pantheon of noted individuals at hand whose lives were the subject of intense scrutiny and popular myth making. It is probably not coincidental either that Warhol made his pronouncement in the year of 1968 when two of the most prominent American leaders – Robert Kennedy and Martin Luther King, Jr. – were assassinated. Although their individual accomplishments had already made them famous, their highly documented deaths sealed their reputation as fallen martyrs, which also brought notoriety to their killers. Thus the Pop interest in fame was double-edged because it encompassed the famous *and* infamous, the victors and victims in post-war life.

As early as the mid-fifties, Peter Blake recorded and openly perpetuated the collusion between famous individuals and the mass media. His painting *On the Balcony* (fig.5) listed what would encompass the Pop pantheon of celebrity. Hand-painted copies of famous photographs of the Royal Family celebrating

its Silver Jubilee on the balcony of Buckingham Palace in 1935 or appearing with Prime Minister Winston Churchill a decade later vie with buttons pronouncing fan loyalty to various pop music stars ('I Love Elvis' and 'I Like the Hi-Los'). Meanwhile the covers of two mass-circulation magazines – *Life* and *Illustrated* – draw attention to the British debutante Julia Williamson and the American actor Danny Kaye respectively. Here we find royalty (in the United States the Kennedy family would fill in), popular music aimed at a youth market, aristocracy and Hollywood celebrity. The latter category is further announced by the figure of Marilyn Monroe, painted on a tie, appropriated from a famous still from the 1955 film *The Seven Year Itch*. The sheer accumulation of printed ephemera in Blake's painting paralleled the obsessive infatuation of fans, and thereby indicated the extent to which the Pop scrutiny of celebrity would mimic the ritualistic consumption of carefully packaged and released information concerning specific individuals.

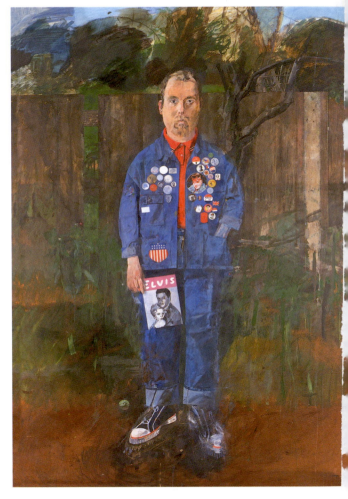

In this regard, we must ask just what the Pop artists were up to – recording an anthropological pattern of post-war behaviour, or actively contributing to it? The answer was both. Like Eduardo Paolozzi before him, and several younger artists soon to follow in the early sixties, Blake took his passion for collecting the artefacts of popular culture into the realm of artistic production. He was a fan. He also made this identity, as well as its attendant activities, an important component of his art as is abundantly evident in his 1961 painting *Self-Portrait with Badges* (fig.26). Here we find the artist identifying himself with youth culture through his consumption of Converse sneakers, denim pants and jacket, a fanzine devoted to Elvis Presley, and numerous badges. Many of these promote American products, from Elvis to Pepsi-Cola. Clearly fame rested on the attention of a rapt audience, including Peter Blake, who willingly celebrated the larger-than-life persona of media celebrities and recognised products.

The popular arts of music and cinema provided several British Pop artists with a recognisable pantheon of stars, whose image and name, in turn,

guaranteed that the paintings had an instantly recognisable iconography. Blake recorded such teen idols as Elvis Presley and the Beatles; Peter Phillips celebrated the fame of movie starlets and sex symbols Marilyn Monroe and Brigitte Bardot. When Blake identified himself as a fan of Elvis, the 'king' of rock 'n' roll had already transformed American popular music, brought his controversial sneer and unrestrained dance to television, survived a stint in the army, and made the transition to the big screen. The Beatles proved to be even more adept at capitalising on the new media, and helped to transform the look of Western culture by the end of the decade. In film, Monroe and Bardot came to signify sexual revolution, and like the most popular musicians, their lives were the subject of intense media interest, as we shall see shortly.

Along with the elevation of talented entertainers to the status of mythic, post-war icons came the exposure of less fortunate individuals whose stories of failure and scandal proved to be equally engaging. In 1963, Great Britain was rocked by an affair that traversed class divisions and Cold War loyalties. That summer Minister for War John Profumo admitted to a romantic relationship with the model Christine Keeler, who was also rumoured to have slept with a Soviet naval attaché. Illicit sex, lying about the affair before the House of Commons, and the possibility of a national security breach were enough to ruin Profumo's career and bring down the government of Harold Macmillan, while simultaneously sustaining a media feeding frenzy. These events drew the attention of Pauline Boty, whose paintings revealed a feminist sensibility concerning sexual hypocrisy. *Scandal*

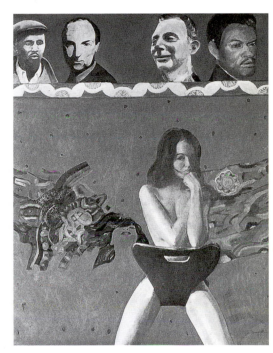

63 (fig.27), which took its title from a popular account of the affair, reproduced a famous image of a nude Keeler astride an Arne Jacobson chair, coolly surveying anyone confident enough to meet her gaze. Through Boty's eyes, Keeler was the central figure in the scandal, a fact often lost in the attention given to a powerful male and his moral weakness.

We can begin to see that the Pop concept of fame was of something that happened to people, either through merit or accident. What counted was that the media focused its attention on someone, whether for a season, as in the Profumo Affair, or for perhaps an entire career, as with Monroe or Presley. Further, we can think of the Pop interest in famous people as an added layer of attention. Designed as both a mirror and a lamp, such Pop art willingly participated in a world obsessed with the wheel of fortune, and revealed just how pervasively the market dictated fame. Not surprisingly, the artists'

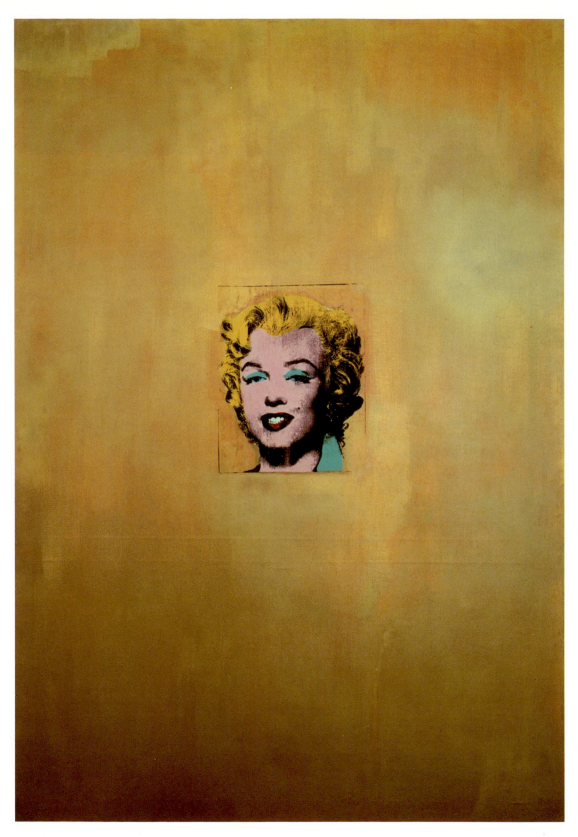

interest in celebrity revealed the extent to which they too were implicated in the perpetuation, and manipulation, of celebrity.

In the United States, Andy Warhol was unique in his life-long attention to fame and fortune, both his and that of others. Like Peter Blake, Warhol was a fan and collector of popular culture. He claimed, in a 1963 interview with Gene Swenson, that Pop was 'liking things', which immediately sets up the problem of unquestioning acceptance (Madoff 1997, p.103). However, we need to remember that his portraits of Hollywood celebrities, who in their role as stars were frequently transformed into commodities, are often tinged with pathos. When he eventually became famous, thanks in part to keeping his name in the daily papers in the sixties, he shifted from media celebrities to the rich and famous of New York, whose own status was enhanced by commissioning a Warhol portrait. Perhaps more than any other Pop artist,

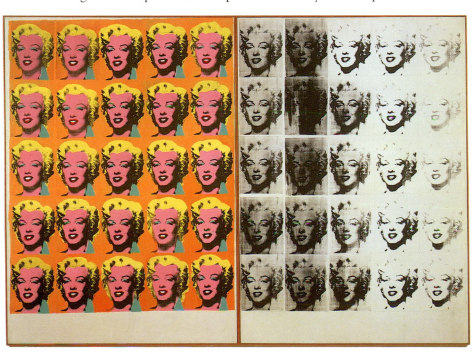

28
Andy Warhol

Gold Marilyn Monroe 1962

Synthetic polymer paint, silkscreened, and oil on canvas
211.4 × 144.7
(83¼ × 57)
Museum of Modern Art, New York

29
Andy Warhol

Marilyn Diptych 1962

Silkscreen ink on synthetic polymer paint on canvas
208.3 × 289.6
(82 × 114)
Tate Gallery

Warhol understood the necessity of easily recognisable and endlessly repeatable images for establishing fame through the mass media.

Although he was infatuated with Hollywood and produced collages in homage to famous entertainers during the fifties, it was not until the fall of 1962 that Warhol found the subject matter and medium for his most important rumination on fame. The occasion of Marilyn Monroe's death and the adoption of silkscreen gave Warhol his first great icon and a medium appropriate to her remembrance. He chose a publicity still from 1953 when Monroe was still youthful and at the peak of her career, cropped it to draw attention to her face — especially the slightly dishevelled hair, full lips and bedroom eyes — and then printed it across a series of canvases. Whether isolated on a field of gold to evoke the otherworldliness of a Byzantine icon, as in *Gold Marilyn Monroe* (fig.28), or repeated obsessively in monochromatic

shades of grey to suggest the heated run of a printing press, for example in the right-hand panel of the *Marilyn Diptych* (fig.29), the imagery worked to frame Monroe within her time and chosen medium of expression. Furthermore, the stylistic references to religious veneration in these two silkscreens – a golden background and the diptych format – deliberately blurred the distinctions between Monroe as a modern-day Magdalen and Madonna. She seems to be both the embodiment of carnal pleasure and the image of ethereal, saintly perfection, especially as her visage fades in and out of view in the diptych.

We cannot really think of these works as conventional portraits, however, because Monroe did not sit for the artist. Instead, we are presented with found imagery appropriated by Warhol. Each likeness is a copy of an image – albeit a highly marketable one – known through the blitz of media that defined her presence over the preceding decade.

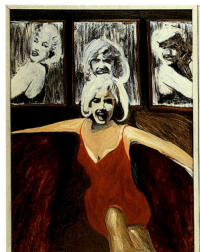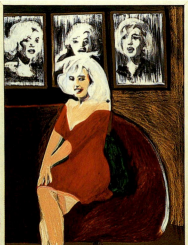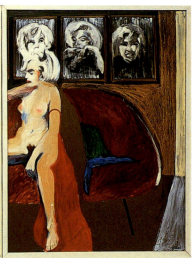

Warhol was not alone in memorialising Monroe, and a comparison between his silkscreens and the images produced by other Pop artists can allow us to discern differences of approach and interpretation with a shared subject. In Los Angeles, James Gill was also mining media images of Monroe, particularly those from a spread in *Life* magazine taken shortly before her death. In *Marilyn Monroe Triptych* (fig.30), Gill utilised a pictorial format – the triptych – conventionally reserved for Christian paintings. In this sense he paralleled Warhol's use of religious symbolism and pictorial format. However, Gill focused on the tension between her full body seated in the foreground and the selective representation of it in *Life* in the background to comment on her vulnerability. Her famous physique, so often exploited in film and photography, is here undressed not to gratify erotic fascination, but to underline emphatically her vulnerability and victimisation.

Throughout the decade several Pop artists drew attention to Monroe's body, which so often was the object of attention on screen. To commemorate

her humble beginnings, Robert Indiana reproduced a well-known cheesecake photograph of Monroe nude, shot before she became a film star, in *The Metamorphosis of Norma Jean Mortenson* (fig.31). Hugh Hefner had already popularised the image by publishing it in the first issue of *Playboy* magazine in 1953. Such exploitative imagery helped make his fortune and fame, while embarrassing the starlet, who, like other unknown actresses in years to come, consented to such 'modelling' to help finance a budding career in film.

30
James Gill

Marilyn Monroe Triptych
1962

Oil on composition
board
Each panel 122 × 91
(48 × 35¾)
Museum of Modern Art,
New York

31
Robert Indiana

*The Metamorphosis of
Norma Jean Mortenson*
1967

Oil on canvas
259 × 259
(102 × 102)
Private Collection,
Courtesy of Simon
Salama-Caro

To acknowledge the importance of photographic images in shaping Monroe's public persona, Richard Hamilton reproduced a series of photographs of the actress on a beach (fig.32). Most of these images are marked with a photographer's strike to remove the prints from circulation. Titled *My Marilyn*, the screen print announced the identification of fans with their heroes and heroines. The 'my' of the title could be Hamilton laying claim to his favourite image of the star. Additionally, the marking of the proof sheet reveals just how carefully imagery was reviewed before being released for popular consumption. The one

photograph not defaced is the most vivacious, and, in fact, was chosen by the actress.

A different reading of the Monroe legend is evident in Pauline Boty's *The Only Blonde in the World* (fig.33). At once identifying the actress as unique among women, the painting also celebrates her bravura performance of a staged feminine desire and swagger. Where the men seem to lament the passing of a revered love object, Boty seems to honour a vivacious model of womanly deportment. In essence, the Pop investigation of Marilyn Monroe

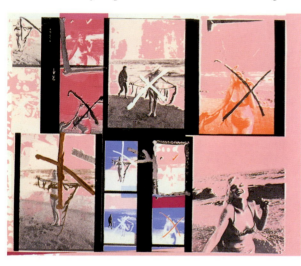

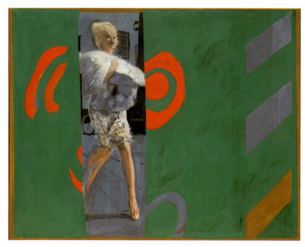

focused on her public persona, that is, on the images through which she was known. It also revealed the variety of personal responses possible in considering a common subject.

All of these Monroe images were produced posthumously, which returns us to the complexity in Warhol's infatuation with fame. Although he made silkscreens of other Hollywood celebrities such as Elizabeth Taylor and Natalie Wood, he is best known for those of Marilyn Monroe, which work to place death at the very centre of contemporary fame. In the following months he would focus on the unfortunate deaths of housewives in Detroit owing to tuna poisoning, suicides, victims of automobile accidents, and the public grieving following the assassination of President Kennedy in *Sixteen Jackies* (fig.34). For Warhol, fame was often a double-edged imposition, an unfortunate turn of events that confirmed human frailty. Fame, we might theorise, was what happened to people. For better or worse, knowledge of what happened to them, as well as how they responded, came through the intrusion of the media. What at first sounded like a democratic and utopian call for recognition – in the future everyone will have their share of fame – on second analysis becomes quite unnerving. Lack of privacy was the price of fame and the underside of the media revolution transforming so much of Western life in the post-war years.

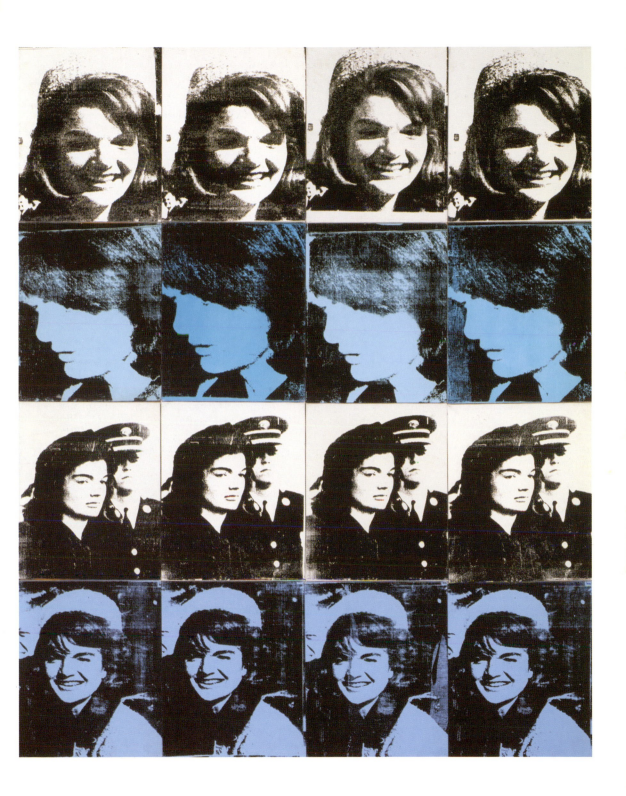

35
Eduardo Paolozzi
*I Was a Rich Man's
Playthng* 1947
Collage mounted on
card
35.9 × 23.8
(14¼ × 9½)
Tate Gallery

HEDONISM

If Pop art was, as Richard Hamilton proclaimed, 'young and sexy', then it certainly had its topical subjects readily at hand, whether in the affluent society of the United States, or in the media-invented 'Swinging London' of the mid-sixties. Pop coincided with dramatic changes in Western society and helped bring these changes into view. In the collage *Just what is it?* (fig.1), Hamilton pictured a host of pleasurable diversions available to consumers. Increased leisure time for the enjoyment of popular literature and music joined a new permissiveness in relation to the body, its representation and consumption. Significantly affecting these social changes affecting the body were advances in birth control – notably the pill, recent legislation in Great Britain and the United States that decriminalised previously 'obscene' literature such as D.H. Lawrence's novel *Lady Chatterley's Lover*, and a booming youth market that focused on the pleasures of the senses.

Sexually explicit materials were increasingly available in the post-war years and were a staple of popular art from science fiction and advertising, to pop music and cinema, as Lawrence Alloway had argued in his 1956 essay 'Technology and Sex in Science Fiction: A Note on Cover Art' (Robbins 1990, p.61). Among the first collages produced by Eduardo Paolozzi in the late 1940s was *I Was a Rich Man's Plaything* (fig.35), which prominently featured a cover for *Intimate Confessions* that promised such steamy stories as 'Woman of the Streets' and 'Daughter of Sin'. That this newly commercialised and sexualised body was perceived as uniquely American is evident from the postcard celebrating United States bombers stationed in Great Britain during

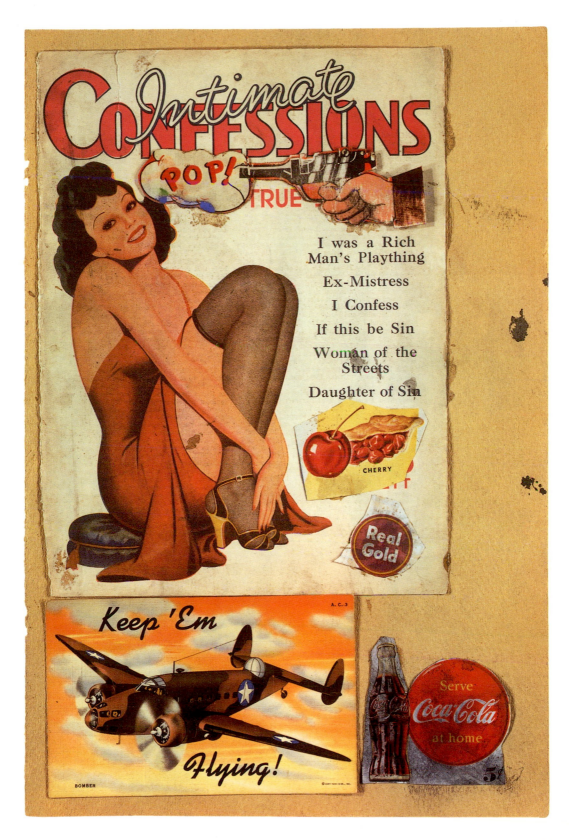

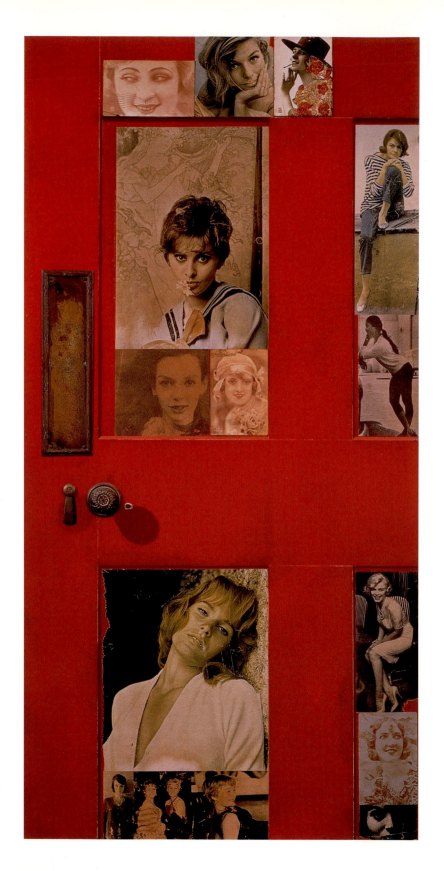

36
Peter Blake

Girlie Door 1959

Collage and objects on
hardboard
121.9 × 59.1
(48 × 23¼)
Private Collection

37
Marisol

Hugh Hefner 1967

Polychromed wood
185.4 × 22.8 × 198.1
(73 × 8⅞ × 78)
National Portrait Gallery,
Smithsonian Institution,
Washington, D.C.

World War II and the advertisement for Coca-Cola, perhaps the one commodity that most readily signified American commercial prowess in the post-war years. The collage is suffused with sexual innuendoes, from the phallic outlines of handgun, bomber and bottle, to the vulgar and obvious triangulation of female genitalia, cherry pie and 'real gold'. As the discharge of the gun reveals, the yeasty product of 'pop' culture is ever ready to impregnate the realm of fine art. A far remove from the nymphs and shepherdesses of classical art, or the chaste nudes of Renaissance painting, Paolozzi's feminine ideal is a decidedly modern creation.

On both sides of the Atlantic the female body figured in several Pop paintings that acknowledged the ersatz culture already evident in Paolozzi's collages. Often drawn from recently released softcore pornographic magazines for men, such as Hugh Hefner's *Playboy*, these pin-ups were tied to the market in that they most often were designed to attract consumer attention, and they were the product of intense heterosexual male fantasy. Hefner, whose enterprise made him a millionaire by 1960, became a model of male commercial and sexual success. His rags to riches story was chronicled in a cover story by *Time* magazine in 1967, which commissioned the sculptor Marisol to produce a free-standing portrait of him (fig.37). His media empire rested on the pneumatic Playmates, whose existence, though clearly evoking the heyday of pin-up production during World War II, was inconceivable without the dramatic changes in legal definitions of obscenity through the late fifties and sixties. Largely through Hefner's efforts, the pin-up became a topical source of inspiration to painters in the post-war decades who wished to consider the female figure, including the nude.

In Britain, Peter Blake acknowledged the importance of pin-ups for adolescent, heterosexual fantasy in *Girlie Door* of 1959 (fig.36). Here the British artist's interest in the tackboard as a repository of visual curiosity and inspiration was given over to the actresses shaping contemporary sexuality, such as Marilyn Monroe and Gina Lollobrigida. Three years later Peter Phillips neatly conjoined a Valentine's Day heart, hard-edged abstraction, and classic forties' pin-ups to suggest the tenor of modern romance and longing in *Forces Sweetheart – Synchronised* (fig.38). The title of the painting, as well as its colour scheme and heraldic row of stars that serve to frame the women in staged poses of enticement, evoked the presence of American troops in Great Britain during the war. His references to American sexuality echoed the Independent Group's vision of the United States as an exotic land of plenty – a modern-day orient of sexual freedom.

In the United States, an equation was often made between an emergent sexual permissiveness and consumer choice. Tom Wesselmann's series of collages and paintings, The Great American Nude, enumerated many of the pleasures available to men in the early sixties. In *Great American Nude #26* of

49

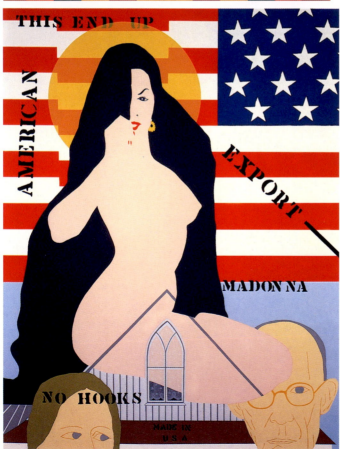

38
Peter Phillips

Forces Sweetheart –
Synchronised 1962

Oil and collage on
canvas
180 × 180
(71 × 71)
Private Collection,
Brussels

39
Allan D'Arcangelo

American Madonna
No. 1 1962

Acrylic on canvas
152.4 × 114.3
(60 × 45)
Estate of the artist

40
Tom Wesselmann

Great American
Nude #26 1962

Mixed media on board
148.6 × 118.1
(58½ × 46½)
Collection of the Robert
B. Mayer family,
Chicago

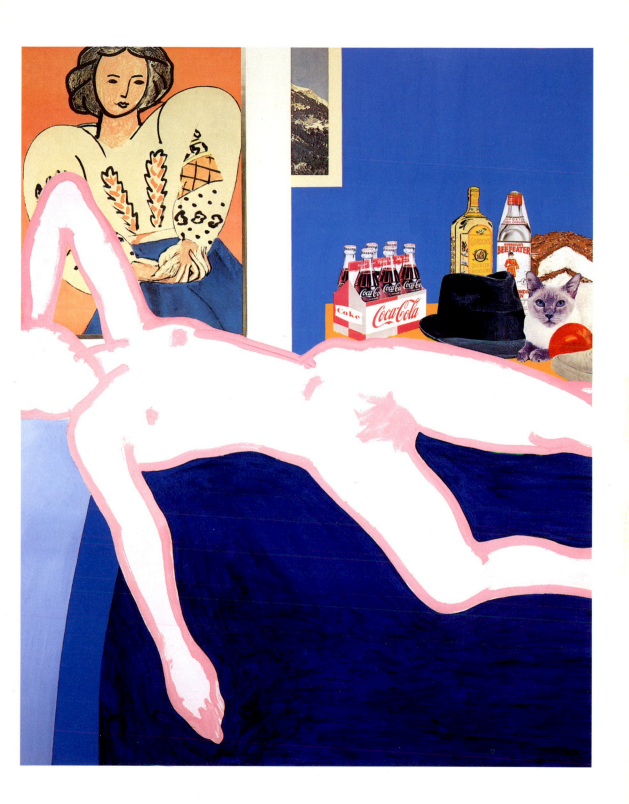

1962, a hot pink female nude boldly holds the space of a domestic interior (fig.40). She is joined by a reproduction of Henri Matisse's *Roumanian Blouse* (1940, Musée National d'Art Moderne, Paris), announcing both Wesselmann's debt to earlier art as well as his distance from it. What marks his nude as a Pop statement is the inclusion of such consumer goods as the six-pack of Coca-Cola, bottles of gin, and the instant cake. Through the addition of the cat, we can discern a reference to Edouard Manet's infamous painting of a prostitute, *Olympia* (1863, Musée d'Orsay, Paris), and recognise that her American descendant is also a marketable commodity. Apparently what was great about the American nude was her availability. Whether Wesselmann was critical of the new hedonism celebrated in *Playboy* and the James Bond films popular throughout the decade remains an open question.

Other artists worried that the new commercial hedonism revealed the American dream to be bankrupt. Allan D'Arcangelo replaced a traditional image of chaste femininity with a calendar girl in his ironic *American Madonna No. 1* (fig.39). Designed for export and promising no hooks or attachments, she had superseded the iconography of an older, agrarian America – Grant Wood's hugely popular *America Gothic* (1930, Art Institute of Chicago) – as well as the traditional Christian imagery of feminine chastity. In the early sixties, a debased pin-up best personified the United States, as well as its commercial and sexual exploitation.

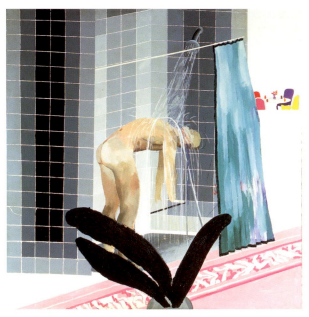

In his 1959 essay 'The Long Front of Culture', Lawrence Alloway noted that the audiences consuming popular culture were 'numerically dense but highly diversified' (Institute for Contemporary Art 1988, p.32). His insight can help us to understand the diversity within Pop art as indicative of multiple audiences who could read their own desires into the artefacts and mementoes of popular culture. Although the Pop treatment of sexual revolution was largely male and heterosexual, there were other voices of desire found within the movement. Pop was also home to gay and feminist artists who helped articulate divergent sexualities in the decade before these critiques of mainstream culture became prevalent. Most noteworthy in this trend was David Hockney who with such paintings as *Man in Shower in Beverly Hills* (fig.41) openly celebrated the erotic allure of the male body, while simultaneously invoking the heritage of classical art and extending the tradition of the nude at her (or his) bath. In a more coded fashion, Andy Warhol announced the mutability of desire by transforming a

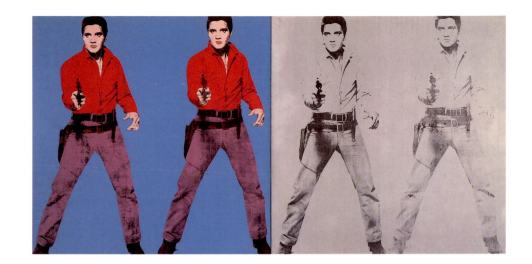

41
David Hockney

*Man in Shower in
Beverly Hills* 1964

Acrylic on canvas
167.3 × 167
(65¾ × 65¾)
Tate Gallery

42
Andy Warhol

Elvis I and II 1964

Left panel: silkscreen
on acrylic; Right panel:
silkscreen on
aluminium paint on
canvas
Each panel
208.3 × 208.3
(82 × 82)
Art Gallery of Ontario,
Toronto

43
Pauline Boty

5–4–3–2–1 1963

Oil on canvas
125 × 100
(49¼ × 39½)
Whitford Fine Art,
London

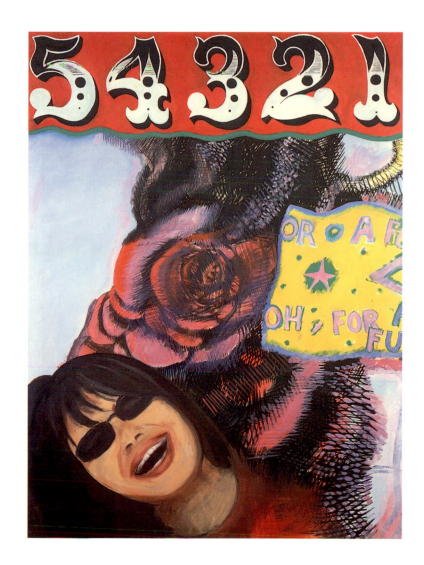

well-known film still of Elvis Presley from the 1960 movie *Flaming Star*, into a high camp drag performance through lavender pants, crimson shirt and rouged lips in *Elvis I and II* (fig.42). For Pauline Boty, the sexual revolution was an opportunity to discuss her desires as a woman. *5-4-3-2-1* of 1963 (fig.43) contrasts the feminine symbol of a rose with a young woman's face and the incomplete but obvious text, 'OH, FOR A FU . . .'. Within a decade, the politics of intercourse and orgasm would be central concerns for feminists who wished to counter the misogyny of the sexual revolution.

Whereas the subject matter of Pauline Boty's painting targeted embodied desire, the title directly quoted the other major strain of youth culture in the

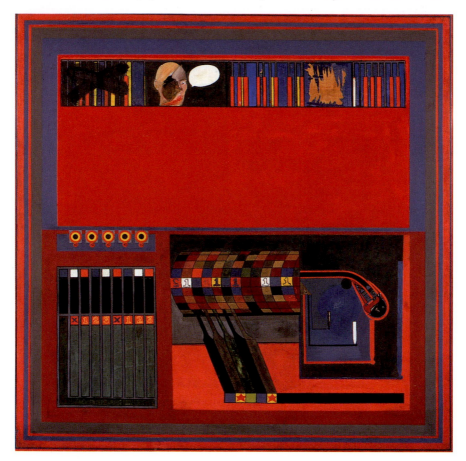

sixties – popular music. The numerical countdown came from the popular pop music programme *Ready, Steady, Go!*, where Boty sometimes danced with fellow Pop artist Derek Boshier. She was not alone in acknowledging music as a major source of inspiration in contemporary life. Her fellow student at the Royal College of Art, Peter Phillips often alluded to jukeboxes in his paintings from the early sixties, as is evident in *The Entertainment Machine* (fig.44). Peter Blake included photographs of Elvis and other pop singers in *Got a Girl* (fig.45). The actual 45rpm record in the collage was the Four Preps account of a teenager's lament about his girlfriend who only thought about these pop idols every time he tried to kiss her.

The large audiences popular music addressed, the subjects of its most popular songs, and the intense media exposure such music needed for success were phenomena readily understood by the Pop artists. In fact, there were healthy exchanges between the two spheres. The Who appeared on stage wearing badges and Union Jacks in clear homage to Peter Blake's paintings, including *On the Balcony* (fig.5) and *Self-Portrait with Badges* (fig.26). Blake, who produced paintings of Bo Diddley and the Beatles in the early sixties, later designed the famous album cover for the Beatles' 1967 release *Sgt. Pepper's Lonely Hearts Club Band*. A year later Richard Hamilton designed the cover for their 'White' album. In the United States Andy Warhol moved into the music scene with his multi-media extravaganza, the Exploding Plastic Inevitable, and its band, the Velvet Underground. While the cover of their first album was graced by a Warhol silkscreen of a banana, the dark content of several songs, which focused on drug addiction, street life and sado-masochism, echoed the nocturnal happenings in the Factory. The Rolling Stones

<div style="float:left">

44
Peter Phillips

The Entertainment Machine 1961

Oil on canvas and wood
182.9 × 182.9
(72 × 72)
Tate Gallery

45
Peter Blake

Got a Girl 1960–1

Oil paint, wood,
photo-collage and
record on hardboard
94 × 154.9 × 4.2
(37 x 61 × 1¾)
The Whitworth Art
Gallery,
The University of
Manchester

</div>

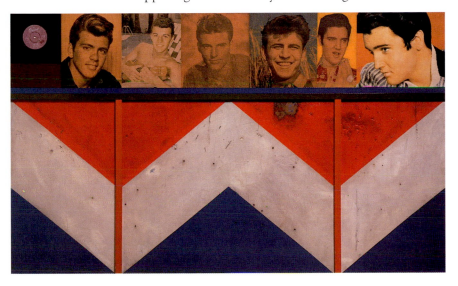

commissioned perhaps their most famous album cover, *Sticky Fingers* of 1971, from Warhol, who later produced several silkscreen portraits of Mick Jagger. Such closeness to music stars helped guarantee the ongoing presence of Warhol, and Pop in general, in Western culture. In some ways this closeness also furthered the Independent Group's original idea of effacing boundaries between fine art and popular culture, although by the late sixties the common bond between Pop and other successful cultural trends was money.

Ever attentive to the friction between youthful hedonism and an older, perhaps more conservative mentality, Pop art noted the rise and troubled times of pop music. When in early 1967 Mick Jagger and Keith Richards along with the art dealer Robert Fraser were arrested for possession of narcotics, Richard Hamilton, who was represented by Fraser, commemorated the event in several silkscreen paintings and a poster. The former reproduced a famous photograph of a handcuffed Fraser and Jagger covering their faces in the back of a car as they were pursued by paparazzi (fig.46). The latter, in

good Independent Group fashion, resembled a fan's scrapbook of headlines clipped from newspapers, most of which sensationalised the story of British youth and illegal drugs while carefully noting what the musicians wore during their arraignment (fig.47). Clearly London was not as 'swinging' as the media suggested it was, although the arrests made for good headlines, as did youth culture in general. To point out the hypocrisy of the tabloid press who first voyeuristically invaded the lives of pop stars such as Jagger and Richards, and then offered the moral reproach of public condemnation, Hamilton titled his work *Swingeing London*. With its play on the words swing and swinge, the title suggested that the protagonists were burnt by the glare of too much media attention, and that they were punished for a lifestyle found to be too unconventional by more conservative members of British society.

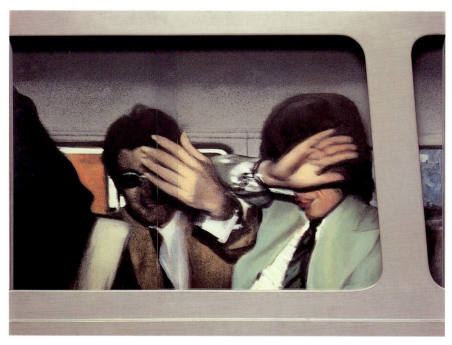

46
Richard Hamilton
Swingeing London 67
(f) 1967
Acrylic, emulsion, silkscreen, ink and collage on canvas
67.3 × 85.1
(26½ × 33½)
Tate Gallery

47
Richard Hamilton
Swingeing London 67
1967–8
Lithograph on paper
71.1 × 49.8
(28 × 19½)
Tate Gallery

By tracking, celebrating and sometimes critiquing contemporary hedonism, whether in sexual behaviour or popular music, Pop art transformed momentary concerns into the material of fine art. Of course the theme of hedonism was not new; it was as old and venerated as Western art itself. What was new was the amount of attention given to the subject, and the sums of money people paid to experience it, whether in film, literature, men's magazines, albums or works of art. We can also see that the ready emphasis on the topical — the here and now — would, with the passing of a season or two, become the there and then. Perhaps like so many painters and poets before them, the Pop artists were freezing the present, memorialising it in order to save it as a distinct moment in what was rapidly becoming the past. Today only makes sense in a continuum between yesterday and tomorrow, which means that we must also look at Pop's nostalgia to assess its awareness of time passing.

STONES: 'A STRONG, SWEET SMELL OF INCENSE'

Robert Fraser and Mick Jagger try to shield their faces from photographers on their way to court today.

Story of girl in a fur-skin rug

BY A SPECIAL CORRESPONDENT
Chichester, Sussex, Wednesday

ONE of the party guests at Rolling Stone Keith Richard's house, when it was raided by police one night last February was a young woman wearing only a fur-skin rug, the West Sussex Quarter Sessions jury heard today.

Mr. Malcolm Morris, QC, prosecuting, said there was a strong, sweet smell in the house. He suggested that it was incense, being burned to hide the smell of cannabis resin, traces of which were found in ash deposits.

Detective Inspector Lynch, Scotland Yard's Drug Squad, said Mr Morris, would tell the court what effect cannabis resin (Indian hemp) had on people.

"It produces an effect of tranquility and happiness and tends to dispel inhibitions," added Mr Morris.

"All she wore"

"It seems to have had exactly that effect upon one of the guests. This was the young lady who was sitting on the sofa.

"All that she was wearing was a light-coloured fur-skin rug which, from time to time, she let fall, disclosing her nude body.

"How people behave in their own houses is usually no concern of anybody else. The only significance of that young lady is that when the police arrived to force she remained supremely at ease and apparently enjoying the situation.

"Indeed, although she was taken upstairs to be searched and into a bedroom where her clothes were, she returned downstairs afterwards where, apart from Mr Richard and his guests there was a large number of policemen, still only wearing that fur rug."

No alcohol

There were no glasses containing alcohol in the drawing-room, said Mr Morris.

He submitted that the reason why Richard was not surprised at the young lady's behaviour was because he knew cannabis resin was being smoked on the premises.

Fans of the Rolling Stones at Chichester today before the hearing.

The agony of seeing your idols jailed...

Tudor-style farmhouse in West Wittering.

REDLANDS, THE HOUSE IN WHICH POLICE SAID THEY FOUND DRUGS

Keith Richards, more soberly dressed in pale-pink T-shirt and jeans, rushed to the court with it in his blue Bentley just before the court adjourned.

KEITH RICHARD
"Party guests"

A crowd of about 50 waited at the rear exit of the court — dressed in an eggshell green jacket with dark green trousers — here.

They rushed Richard's blue police van drove out, but it was a false alarm. Only policemen were inside.

Keith Richard.

Redlands is a beautiful old thatched farmhouse partly surrounded by a moat. It is in a secluded position at the end of a lane in West Wittering, Sussex, and is owned by Keith Richards of the Rolling Stones.

Proper course

The Editor of the News of the World was made aware of the information. He decided that since there was no doubt of the informant's sincerity.

A third man, Robert Hugh Fraser, aged 29, art gallery director.

on Robert Hugh Fraser, aged 39, London art gallery director, for possessing 24

Mr. Fraser runs an avant-garde gallery where works by contemporary and pop-type artists are often on view.

ROBERT HUGH FRASER

Art man's sentence to stand

REGINA v. FRASER

Before the LORD CHIEF JUSTICE, LORD JUSTICE WINN and Mr. JUSTICE CUSACK

Incense found

Mr. McCowan said that when he officers arrived at Richard's house they noticed a very strong, sweet and unusual smell.

Police found sticks of incense and a tin which appeared to contain incense

Rolling Stone Brian remanded

ROBERT FRASER
Runs a gallery

Lord Parker said that Fraser, of Mayfair, the son of a merchant banker, was educated at a famous public school and served in his recognised regiment.

"The main group of the court had arrived at Redlands in 11 and 12 midnight on Saturday night, followed by the married couple. "Everyone was a little hungry so I cooked some eggs and bacon."

Fraser (29), of Mount Street, Mayfair.

Pop idol Mick Jagger of the Rolling Stones went to court today in a lime green jacket, dark green trousers, a green and black tie and a floral-pattern white shirt to answer drug accusations.

MOD-STYLE SUIT AND STRIPED SHIRT

Keith Richard stood in the dock wearing a four-button Mod-style black suit and a Regency-striped, high-necked shirt.

GREEN JACKET
CHANGE OVER

Jagger wore a double-breasted green jacket, cream silk shirt and fancy grey tie in court and Richard had a black coat and orange tie.

After lunch they appeared wearing each other's jackets.

MICK JAGGER
Eggshell-green jacket

Black suit

Remanded on bail yesterday.

KEITH RICHARD—he wore a black four-button Regency style suit, trimmed with black braid. With it he had a white high-necked shirt.

WHITE TABLETS

On the case against Fraser, Mr. McLewan said a police officer behind the drawing room door found inside the right-hand pocket he took out eight green capsules and handed them to a constable.

Jagger, wearing a yellow frilly shirt and black tie with a light green jacket stepped up to the dock. Slowly and sedately he passed the sentence and was led into the room while holding his head and whistling softly.

Jagger, 23, had earlier been found guilty of possessing Italian pep pills.

Granting Mr. Jagger an appeal certificate, Judge Block told Mr Havers: "I wish you the best of luck."

MICK JAGGER, in frilly orange shirt and embroidered tie, celebrating his freedom in a Fleet Street public-house last night. At his elbow—a slice of vodka and lime. wore a lime green

MICK JAGGER, lead singer in the Rolling Stones pop group, arrived at a court yesterday in a blue Bentley. He left last night in a grey van—bound with other men on remand to spend a night in Lewes Jail, Sussex.

JAGGER APPEAL
"Wish you luck"

When the case against Jagger ended, Mr. MICHAEL HAVERS, Q.C. defending, intimated there would be an appeal on a point of law.

JAGGER, 23, wore a pale green double-breasted jacket with white buttons, olive green trousers, a floral shirt and green and black striped tie. He sat in the dock beside Richard, who pleads not guilty.

Richard, with hair down the back of his neck like Jagger, wore a navy blue frock coat, black military-style trousers, a lace collar and maroon and black shoes.

Mr. Jagger appeared dazed after the Judge had passed sentence.

About 20 minutes after the sentences had been passed a blue Bentley with darkened windows drove out of the back entrance of the court and sped off in the direction of West Wittering. It returned about 20 minutes later and drove straight into the rear entrance again.

Miss Marianne Faithfull, the singer, got out and went up the steps into the court building. She was crying.

KEITH RICHARD
Screaming guitar

'TABLETS WERE FOUND IN A GREEN JACKET'

In London today
near Brian Jones.

Brian Jones, 25-year-old Rolling Stones guitarist, and Prince Stanislas Klossowski de Rola were remanded on £250 bail at West London today on a drugs charge.

The two, who were "mod" gear and arriving in a Rolls-Royce, were accused of the unauthorised possession of cannabis resin (Indian hemp).

Prince diamslas in brown a "Mr. Rola" father is a director of a Hollywood bank. He played several small roles in Hollywood before joining the pop world.

Jones appeared in suit, a long a blue lounge suit, a white shirt with lace cuffs and a large blue and white polka-dot tie. Prince Stanislas wore a brown fastype coat over a blue suit.

When the two men left the court after the two-minute hearing, a crowd of about 50 people was waiting, many of them young girls, some of whom screamed "They're gorgeous."

The two drove away in a silver Rolls-Royce.

ROBERT FRASER

SPECIAL JASMINE

In pipe

Also on the table was a briar pipe-bowl. This was taken away and on analysis the contents were found to contain traces of cannabis resin.

The constable was, sentenced and searched him. The constable took from a pocket a tin containing pieces of a brown substance and a decorated envelope

Shown the briar pipe bowl the police found in the house, Det. Richard said it originally came from Los Angeles, where it was given to him by an American road manager, contain 66 grains of cannabis resin.

There was also an envelope containing herbal cannabis—untreated hemp—and a substantial ball of brown substance which when analysed turned out to be 130 grains of cannabis resin.

Detective Inspector John Lynch, of the Drug Squad at New Scotland Yard, said it was normal practice to toss slices of cannabis or incense to be burned to nullify the smell of cannabis smoke.

Det Sgt Cudmore said a well-known national newspaper gave him the information which led to the visit to Richard's house.

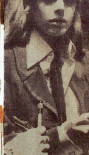

Marianne Faithfull, 20-year-old pop singer and girl friend of Mick Jagger—the last seen here signing autographs in Chichester today was taken to Mick Jagger in the Sussex cells this evening.

Earlier Marianne Faithfull, to see Jagger but sent in a

draughts board and 30 cigarettes.

She wore a two-tone brown jacket over a light green skirt and had large soft boots on her feet.

Mr Jagger and Fraser had lunch sent into the cells from a local hotel.

ROLLING STONE
Mick Jagger is driven to jail in a police van last night after receiving the nine months in jail.

With him he took three books—one about art, another about Tibet—and tipped cigarettes, a bar of chocolate and a jigsaw puzzle.

Also a suitcase full of clothing was brought for him.

Stones: switch on way to court

Evening Standard Reporter
CHICHESTER, Wednesday.—Police were on duty ready to stop any fan scenes when the Rolling Stones' Mick Jagger and Keith Richard appeared on drug summonses at Chichester today.

They were excused together with Wm. End art gallery director Robert Hugh Fraser, of Mount Street, Mayfair, of offences under the Dangerous Drugs act alleged to have occurred at Richard's home at West Wittering.

After lunch, Mr. Jagger had changed his bright green jacket to one of charcoal grey and Mr. Richard had changed out of a jacket with black black and white stripes into green.

Wittering. Richard's country home, a few miles from Chichester. They left for the court in a Daimler but changed to another car on the way to a Minor 1000.

It drove over narrow roads. The car was mostly a muddy along the narrow lane at through blue and bumpered slip and guard inside.

MICK JAGGER

Jones (of the Stones) on drug charge

One of the Rolling Stones pop group, (Lewis) Brian Jones (25), was charged in Kensington last night with unlawful possession of a dangerous drug—cannabis resin.. He is to appear in West London court today.

Charged with him—and also he is in court today: Stanislas Klonowski de Rola, Baron de Witte-ville (24), Swiss-born entertainer. Both were bailed.

The charges followed a Yard drug squad raid yesterday.

Stones for trial

Mick Jagger (23), lead singer of the Rolling Stones pop group, Keith Richard (23) and art gallery director Robert Hugh Fraser (29).

Pop idol Mick Jagger

at Mr. Havers, helped by his Junior, produced a large fawn and white fur rug with orange lining, holding it up between them. Mr Havers said: "It is an enormous thing. It is a bed cover."

(Proceeding)

WOODEN PIPE
Plastic Phial
Italian writing

The phial containing the tablets had Italian writing on.

From Milan

The phial containing the tablets had Italian writing

NEWS SUMMARY

Green capsules BROWN SUBSTANCE
like a James Cagney film except everything went black.

My clothes were taken away and I was dressed in blue prison uniform, but you don't care what you look like in a place like that."

Meal in a cell for Mick Jagger

HOTELIER Arthur Collings carries meals to the court yesterday for Mick Jagger and Robert Fraser.

The two men, found guilty of drug offences on Tuesday, ate in cells

Moroccan cooking

Describing the day's events before the raid Richard said that they had been to the beach and on a mystery tour. In the evening a Moroccan servant of one of the guests cooked a Moroccan dish, highly spiced, for a buffet dinner.

Afterwards they switched on the television without the sound and played records. Asked about using incense, Richard said he had used it for some time. "I picked it up from fans who used to send me joss sticks." It was not done to cover up the smell of drugs.

below the court, where they waited all day.

For Jagger there was prawn cocktail, roast lamb and mint sauce, fresh strawberries and cream, and two half-bottles of Beaujolais.

Fraser had red melon, fresh salmon salad and strawberries and cream.

KEITH RICHARD

KEITH RICHARD

SWINGEING LONDON 1967
Richard Hamilton
Rita's proof

Richard Hamilton and the gallery's undaunted secretary

6

Today's Yesterdays

One means of identifying what was unique about the present was through reference to the past. We have already seen the art historically retrospective mood of American and British art in the fifties. However, using previous history to justify one's moves in the present is not the same thing as longing for the past, although the two were sometimes inseparable. Several of the Pop artists, especially in Great Britain, were nostalgic, which softened the brash commercialism and cool, anti-romantic sensibility of the movement. Further, preserving or even quoting the past revealed discontent with the hectic pace of the present, while possibly intimating that Pop wanted to maintain cultural distinctions rather than undermine them. Nostalgia was a part of Pop from the moment Richard Hamilton first reproduced *Just what is it?* (fig.1). For all its forward-looking ambitions, the exhibition *This is Tomorrow* was perceived by the critic Basil Taylor as 'pervaded by nostalgia,' because of its clear acknowledgement of previous triumphant moments in modernism (Robbins 1990, p.229). When in 1969 the American critic Harold Rosenberg summarized the arrival and development of American Pop, he noted the prevailing mood of nostalgia in so much of the movement (Madoff 1997, p.183). These critics were entirely correct in their assessment because Pop was often backward-looking, particularly in its choice of subject matter.

Several Pop artists examined the academic subjects of history, portraiture, landscape and still life, as well as the utterly traditional subject of the reclining female nude. In the seventies and eighties Warhol's status as

a fashionable portraitist in New York rivalled the popularity of the best nineteenth-century society painters. Meanwhile Lichtenstein's popularity rested on his continuous quotation of noted styles and movements in modern art. In the late sixties he appropriated Claude Monet's haystack series, while in the seventies he produced several still lifes incorporating gold fish bowls in homage to Henri Matisse's famous use of the motif. Tom Wesselmann's output after 1961 alternated between reclining female nudes and still lifes. We can even suggest that the Pop commentary on contemporary life, whether in Rosenquist's *President Elect* (fig.16), Warhol's Death in America series, or Lichtenstein's heroic war paintings that derived from comic books, such as *Whaam!* (fig.49), echoed the grand life-and-death themes and daunting size of official history painting dating to the previous century. Indeed, the

48
Peter Blake

Toy Shop 1962

Mixed media
156.8 × 194 × 34
(61¾ × 76½ × 13½)
Tate Gallery

infatuation with contemporary morality, with exoticism and escape, not to mention the vast public acceptance of the movement, made Pop seem more like nineteenth-century academic painting than any avant-garde precursor, the obvious debt to abstraction notwithstanding.

The Pop artists who were actively interested in nostalgia were British, notably Peter Blake and David Hockney. In 1963 Blake claimed that Pop art was 'often rooted in nostalgia; the nostalgia of old, popular things', that he wanted to preserve or recapture in the present (Livingstone 1991, p.155). An excellent example is his *Toy Shop* (fig.48), which placed behind a mock store front Union Jacks, tin automobiles and airplanes, plastic soldiers, targets and other assorted mass-produced items from his childhood. The feeling generated is inescapably romantic, and underlines the Pop art desire to force

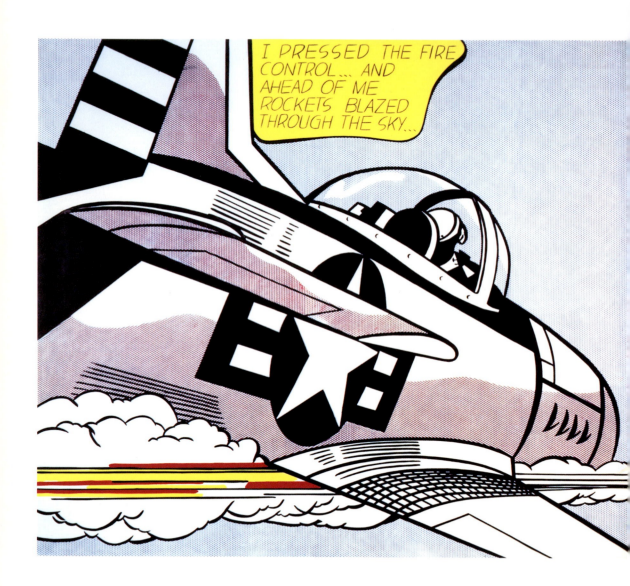

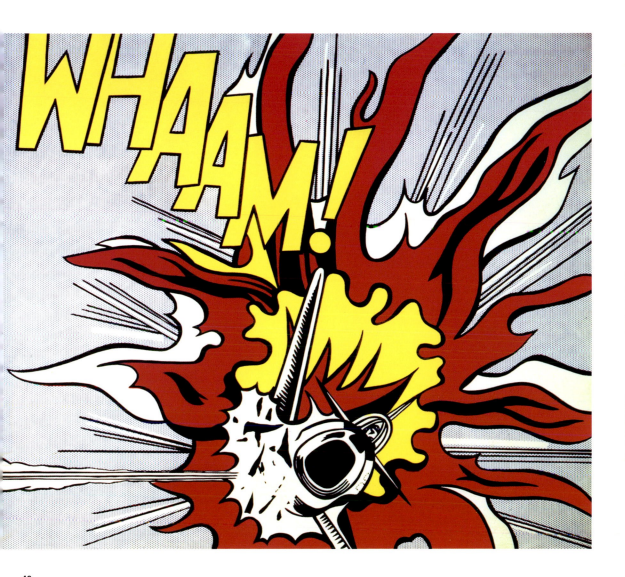

49
Roy Lichtenstein

Whaam! 1963

Oil and magna acrylic
on canvas
172.7 × 406.4
(68 × 160)
Tate Gallery

viewer recognition of otherwise overlooked objects by imbuing them with the force of the magical. Here we can think of nostalgia as an impetus toward careful, nearly reverent looking, and as evidence that the roots of the post-war movement lie in the childhood years of its major practitioners.

Hockney likened the exotic element in his earliest paintings to 'nostalgic journeys', which allows us to perceive the traditional subjects in his paintings, such as landscapes and the figure, as fulfilling his desire to experience life outside of contemporary London (Livingstone 1991, p.157). In *The First Marriage (A Marriage of Styles I)* (fig.50), a well-dressed man in contemporary coat and tie is coupled with a woman whose red skin and body decoration

make her look vaguely Native American, while the palm tree and swaying grass suggest a tropical location. The strong emphasis on rigid body posture, profile view and hieratic pose of the woman also invokes ancient Egyptian art, which further extends the Pop appropriation of previous styles to the very roots of art itself.

To understand this nostalgia for different times or places, we need to recall the conditions under which Pop flourished, as well as the relative ages of the artists. While Great Britain was just emerging from post-war scarcity in the mid-fifties when Hamilton and Blake produced their first identifiably Pop works, the United States was well into its economic boom, which would

indicate that the two countries were at different stages in their economic health. However, if we look carefully we can discern an infatuation with affluence after a period of scarcity and rationing in the United States too. When Peter Blake was 17, Great Britain was still using rationing; when Roy Lichtenstein was the same age, the United States was slowly emerging from the Depression. This indicates that some measure of economic hardship was a shared experience for the Pop artists, and some memory of it haunts their work.

This memory is necessarily more complicated in the United States because the artists had experienced at least the promise of wealth longer than their British colleagues. Yet one common thread running through American Pop's overt recognition of the past is an acknowledgement of the Depression when most of the artists were boys. Many of Claes Oldenburg's favoured motifs in the early sixties, such as flags and guns, were first explored in the scrapbooks he kept as a child in Chicago before the war. The themes of abundance, glamour, fame and heroism can be identified in American culture during the Depression – whether fostered through Hollywood film or satirised in novels, such as *The Day of the Locust* (1939) by Nathanael West – and all resurface thirty years later in Pop. We need to remember, for instance, that the Coca-Cola and Campbell's soup trademarks repeated by Warhol were common brand names during the thirties, available to anyone for a few cents. Hollywood glamour seemed to reach a peak at this moment. And although he could not have known it at the time, Warhol was tracing the demise of the old Hollywood star system in the early sixties. Marilyn Monroe, Natalie Wood and Liz Taylor were products of the big studios and attendant publicity machine that had sustained American film since the Depression.

50
David Hockney

The First Marriage (A Marriage of Styles I) 1962

Oil on canvas
182.9 × 214
(72 × 84¼)
Tate Gallery

51
Mel Ramos

Superman 1961

Oil on canvas
101.6 × 76.2
(40 × 30)
Collection of Skot Ramos, Burbank, California

Mel Ramos and Roy Lichtenstein made their first fully Pop statements by using heroic male characters from the comics first introduced in the decade before the war. The figure in Ramos's *Superman* (fig.51), like Lichtenstein's *Popeye* (fig.52), is a model of masculine strength and fortitude. Both characters were immensely popular during the thirties, as were Dick Tracy, Batman and Robin, and many other comic book heroes. Reviving them in the sixties, no matter how ironically, was a backward glance to a simpler moment when, apparently, men were men and mastered fate with their fists. The theme was repeated by Lichtenstein in 1962 when he turned to war comics, many of which commemorated the triumph of the American military in World War II.

Abundance and fame, as well as fortitude and victory, are central themes in American Pop in the early sixties. As much as they were part of the national

narrative during the Kennedy administration, they also invoked powerful myths in the United States that were by no means new. When the critic Sidney Tillim first reviewed Pop art in early 1962, he read the unmistakable lure of nostalgia within the movement as a reassertion of the American Dream, or at least as a willingness to believe that such a dream existed. Amidst the plaster food, clothing and jewelry in Claes Oldenburg's *Store*, Tillim was thrown into a rumination on the way things were in the past and the way they are in the present. In relating the performance to a cross between a neighbourhood business and a large department store, he neatly situated Oldenburg's event between a retrospective re-enactment of individual, entrepreneurial America and the rise of corporate capitalism.

His reading of Pop's retrospection cuts to one of the central paradoxes of

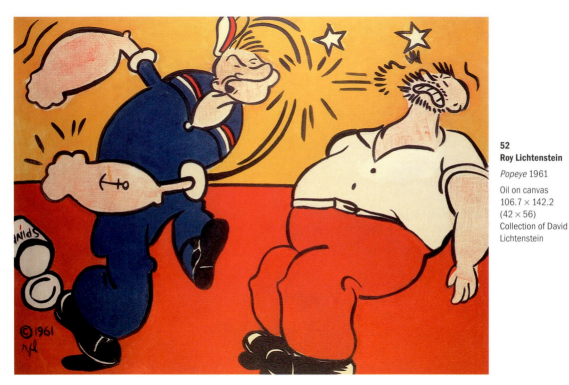

52
Roy Lichtenstein

Popeye 1961

Oil on canvas
106.7 × 142.2
(42 × 56)
Collection of David
Lichtenstein

the movement. Although Pop imagery was frequently mass-produced and therefore widely available, it was subject to highly personal consumption and interpretation. This consumption was often tinged with a strong dose of fantasy, as the artists transformed these preformed materials into objects of individual discovery. Here we need to think of Blake and Warhol's identity as fans, or of Paolozzi's enchantment with America. The Pop artists aspired to be naive sophisticates, children adept in the adult languages of mass media and big business who nonetheless perceived the contemporary world through wistfully retrospective eyes. Of course this was only a desire or pretence, but it helped them measure the co-ordinates of the present. Why they might have felt the need to confront the present by looking backward will be examined in the following section.

TROUBLED TIMES

By the late sixties, when Pop was fully assimilated into the canon of twentieth-century art in an exhibition at the Hayward Gallery in London, whatever critical promise contained in the initial theoretical formulations offered by Alloway, Hamilton and Oldenburg was largely gone. Whether intentionally or not, Pop did not change the definition of art or its hierarchical pretensions. Instead, it helped revitalise apparently outdated subjects. The avowal to remove the boundaries between art and life turned out to be a broadening of art's domain. The American critic Harold Rosenberg summarised the problematic relationship between Pop and its times in his 1969 essay 'The Art World: Marilyn Mondrian'. He noted, 'It might be added that the rising curve of aestheticism in the sixties, with its concept of the world as a museum, represents a withdrawal by the art world from the intensifying politico-social crisis and intellectual confusion in the United States' (Madoff 1997, p.182).

There is some truth to Rosenberg's complaint. However, in its attention to the present, Pop revealed the tensions of a moment that was by no means untroubled. Because the boom economy that sustained Pop's rise and reception was based on an undeclared war, the affluence enjoyed by Americans cannot be separated from the turmoil and anxiety of the Cold War. Already we have seen that the plethora of commodities available in the post-war years could be understood as part of the promise of the capitalist West, with scarcity and limited consumer choice identified with Communism. If we look carefully, we can see that for all its interest in mass media and consumer

goods, fame and hedonism, nostalgia and previous art, Pop was also concerned with the underside of the American Dream.

For instance, if we review Robert Indiana's *American Dream I* (fig.53), the first in a series on that fabled concept, we find that the 'cool' aesthetic associated with Pop could come with potentially hot content. In a visual field subdivided by four circular emblems with several stars derived from the national flag, Indiana equates the promise of America with the chance gamesmanship of pinball and gambling. The overall brown colouring of the painting lends to it an almost funereal pallor, which significantly undermines any reading of these motifs as triumphal. For Indiana, the American Dream is one of winner take all, as the painting pronounces. And if only one person or country could win, then surely someone else had to lose.

53
Robert Indiana

The American Dream I
1961

Oil on canvas
183 × 152.7
(72 × 60)
Museum of Modern Art,
New York
Larry Aldrich
Foundation Fund

54
Derek Boshier

England's Glory 1961

Oil on canvas
141.6 × 127.6
(55¾ × 50¼)
Museum Sztuki, Lodz

55
Colin Self

*Leopard Skin Nuclear
Bomber No. 2* 1963

Painted wood,
aluminium, steel and
cloth
9.5 × 80 × 42
(3¾ × 31½ × 16½)
Tate Gallery

A similar fear of loss, coupled with the potential for total annihilation, surfaces in the work of some British Pop artists who worried about what might happen to their country if the United States and the Soviet Union went to war. A painting utilising the Union Jack and a minuscule figure of Britannia by Derek Boshier in 1961, *England's Glory* (fig.54), seems only to be about the decline of the British empire. The small speech bubble, with text reading 'England expects every man to do his duty', harks back to the country's heroic battle against France during the Napoleonic wars. Yet in a year that witnessed the failed Bay of Pigs invasion, as well as the resumption of nuclear testing after a three-year moratorium, another text placed centrally in the painting expresses the profound anxiety caused by nuclear brinkmanship. A small map of southeastern England with a 'megaton' blast circle inscribed on it reveals how much of the country would be destroyed if London was subjected to nuclear attack. When combined with a prominent, and seemingly growing United States flag in the upper left corner, Boshier's concerns over being caught between the struggle of two superpowers seem very real indeed. In the year following the Cuban missile crisis that very nearly took the United States to war, Colin Self protested the presence of the American Air Force in Britain in his *Leopard Skin Nuclear Bomber No. 2* (fig.55).

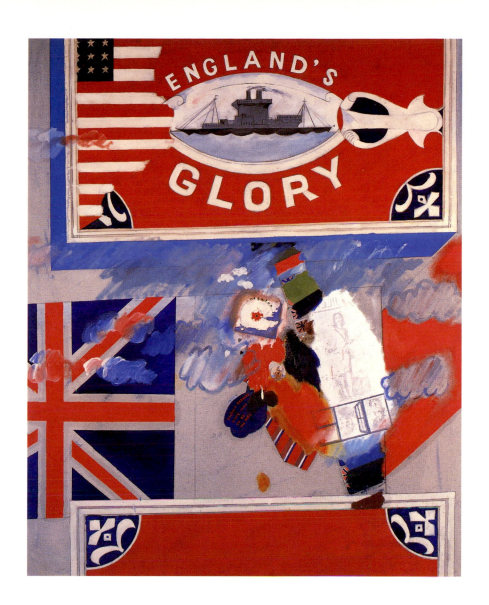

A nasty little sculpture that combines animal aggression with sleek technology, the bomber helped encapsulate Self's anxiety living on a future battleground should the Cold War go hot.

The technological advances that made the Cold War so potentially catastrophic were developed alongside those technologies that made post-war living so different, and so appealing, to remember Richard Hamilton's original question about modern homes. But the same means of mass communication listed within his collage – particularly newspapers and television – often carried images of profound trauma. One compelling story that coincided almost exactly with the rise and fall of Pop was that of African Americans struggling against a set of archaic and racist laws in the American South. While working on his American Dream series, Robert Indiana also turned his attention to Selma, Alabama. In 1965, state troopers armed with tear gas and billy clubs assaulted a group of civil rights demonstrators who were in town to protest the killing of a young black man by local police. The event was broadcast around the nation and generated immediate condemnation. Leaving no doubt as to his sympathies, Robert Indiana was quick to equate the city and state with the basest of human functions in his painting, *Alabama* (fig.56). Meanwhile, Andy Warhol had included in his Death in America series a famous photograph of Birmingham police attacking black protesters with fire hoses and attack dogs. The image repeated several times in *Red Race Riot* (fig.57) was widely known through *Life* and *Time*. Warhol's selection was one that kept the event permanently in place as a form of ongoing protest against American racism.

The Death in America series, which held Warhol's attention while he was also churning out his popular images of Coca-Cola and Campbell's Soup cans, featured car wrecks, suicides, a mushroom cloud and an electric chair. All of the silkscreens derived from media sources, and each could be read against the upbeat narrative of post-war life in the United States. The destroyed automobiles significantly lessened the glamour and sexual innuendo of riding the open road, while the suicides (most famously that of Marilyn Monroe) suggested the rift between media promises of health and happiness and the very real desperation of lives that did not find a place in such one-dimensional narratives. In 1965 a mushroom cloud marked twenty years of life with weapons of mass destruction, ones nearly used during the Cuban missile crisis only three years earlier. The electric chair, the most public emblem of Americans' belief in capital punishment, carried specific connotations through the sixties. The decade began with the execution of Caryl Chessman, convicted of sex crimes ten years previously, and witnessed intense, and eventually successful, public activism against such punishment. As exemplified in *Electric Chair* (fig.58), this modern instrument of death is as stark and horrifying as a medieval implement of torture. The Death in America series significantly mitigates our ability to read the Pop movement as unapologetically accepting of contemporary life. Not simply commodities resold as works of art, Warhol's silkscreens are also bitter condemnations of a culture of abundance and violence, of hedonism and death.

Perhaps the most focused complaint directed against the 'affluent society'

56
Robert Indiana
Alabama 1965
Oil on canvas
177.8 × 152.4
(70 × 60)
Miami University Art
Museum, Oxford, Ohio

was the widespread public debate over the United States' involvement in the war in Vietnam. Like civil rights agitation, the American interlude in South-East Asia mapped onto the years of Pop. As Johns and Rauschenberg were developing their signature styles in the mid-fifties, the Eisenhower administration was already sending advisers and aid to Vietnam to check the spread of Communism. Whereas most of the American Pop artists avoided commenting on the war directly, James Rosenquist did so in a large, mural-sized painting that conjoined consumer pleasure with advanced military technology. The fighter-bomber commemorated in *F-111* (fig.59) was to be the latest, and most efficient, tool in American aerial firepower. It was never built, but its projected costs were the subject of intense congressional debate, especially as the war in Vietnam escalated. Perhaps the most disturbing visual

57
Andy Warhol

Red Race Riot 1963

Silkscreen print on canvas
315 × 210
(124 × 82⅜)
Museum Ludwig,
Cologne

58
Andy Warhol

Electric Chair 1964

Screenprint and acrylic on canvas
56.2 × 71.1
(22 × 28)
Tate Gallery

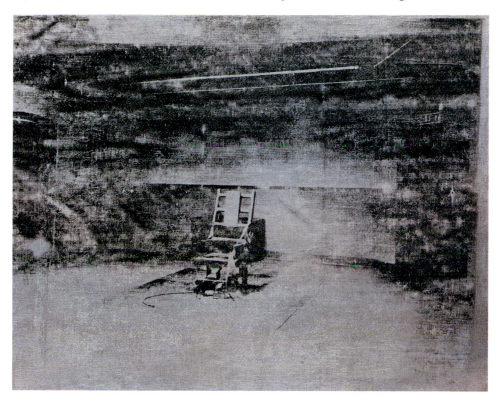

connection in a painting that linked angel-food cake with a Firestone tyre, and an umbrella with a mushroom cloud, was the substitution of the pilot's cockpit with the overly large head of a stereotypically cute little girl. Her blonde hair and pixyish smile, paradoxically, are situated beneath a bullet-headed chrome metal hair dryer. Here marketed innocence supplanted professional warfare to suggest that a still youthful nation could nonchalantly carry out mass killing. To conclude this unnerving equation between innocence and evil, Rosenquist had the fighter-bomber end in a pool of spaghetti, as if after a day at the front one could return to the comfort of home for a warm meal. *F-111* is the most overt protest against the United States' involvement in Vietnam produced by a Pop artist. Inspired by

eyewitness reports about the war, Rosenquist combined technology and consumerism in a luridly saturated colour scheme to shock his audience into recognizing the economic and military symbiosis within American imperialism.

Glut and overload are powerful visual metaphors in Pop art, particularly those works concerned with affluence, but they could also be used to address the problems of contemporary life. Warhol's serial repetition of devastating events, or even the banal products of capitalism, worked to overwhelm his viewers, to subsume them in a sublime excess of things and events over which they had no control. Rosenquist's condemnation of the military-industrial complex extended to 86 feet (nearly 2,622 cm), which made it impossible to take in at a glance, especially when it was wrapped around four walls at the Leo Castelli Gallery, New York, in 1965. On second glance Tom Wesselmann's

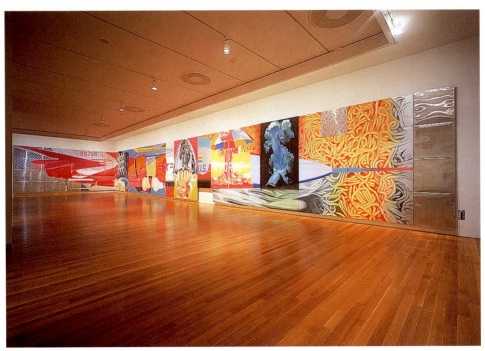

59
James Rosenquist
F-111 1965

Oil on canvas with
aluminium
304.8 × 2621.3
(120 × 1032)
Museum of Modern Art,
New York

60
Robert Rauschenberg

Buffalo II 1964

Oil and silkscreen on
canvas
243.8 × 182.9
(96 × 72)
Collection of the Robert
B. Mayer Family,
Chicago

domestic interiors seem to have too many commodities for the modest space they fill. Lichtenstein's comic-book derived paintings, like Oldenburg's food sculptures, are far larger than their inspiration, and are certainly too big to consume in a gulp. Indeed, overload is both a compositional strategy and an important subject in American Pop. Therefore, it should not surprise us to find one of the progenitors of the movement using overload to great effect throughout the sixties.

Robert Rauschenberg continued to be a source of generative ideas and practices during the second full decade of his prolific career. At about the same time Warhol turned to silkscreen, Rauschenberg did too, although with a markedly different sensibility. Where Warhol used the repetitive possibilities of the medium to focus on one highly charged image, Rauschenberg generated a densely layered and congested surface packed with a surfeit of

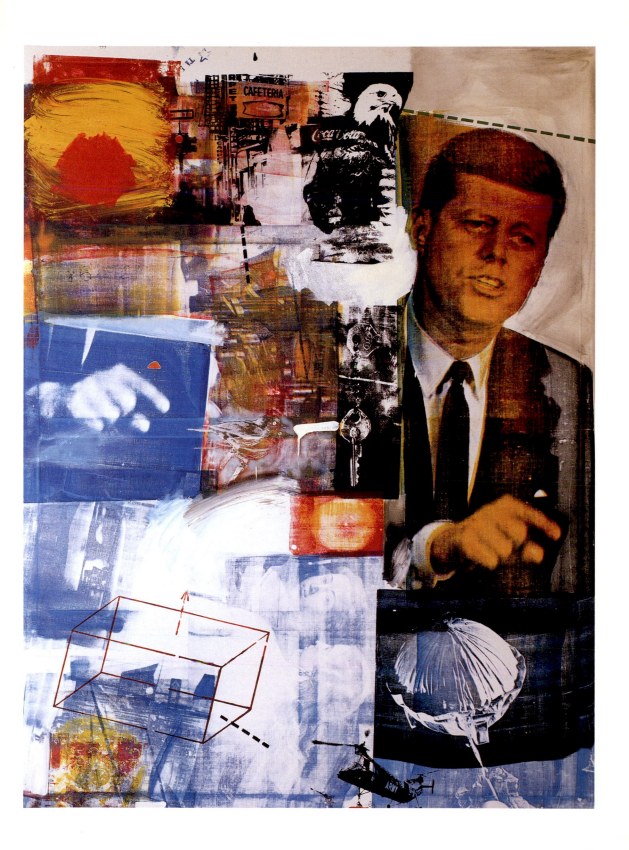

images. No one image can stand out in his screen paintings, which makes all of them potentially of the same visual weight. In *Buffalo II* (fig.60), a famous photograph of the recently slain president shares the stage with, among other recognizable images: a bald eagle, a Coca-Cola sign, an army helicopter, and a parachuting astronaut. In turn, these images invoke the issues of environmentalism, consumerism, Vietnam and the space race, respectively. All are images easily identified with American history in the sixties, and yet each vies for viewer attention. The effect is like surfing the channels on a television or rapidly flipping through the pages of a magazine. Too much information is given at once without any guiding narrative to help one make sense of it. Even the young president, noted for his physical charisma and media savvy, seems overwhelmed and oddly silent within the web of visual white noise.

For Rauschenberg, the effect caught the pace of contemporary life, which brings us back to Harold Rosenberg's lament about Pop art at the end of the sixties. It is true that in aestheticising life, Pop transformed the contents of the world into a museum, but it does not necessarily follow that this manoeuvre indicated a withdrawal from political engagement. As we have seen, the Pop artists could conceive of their work as a form of occasional political commentary. However, the world in which they lived was not susceptible to the simplistic sloganeering of political posters. Friend and foe, right and wrong, were slippery terms at best in the Cold War, especially when one's country was engaged in hostile behaviour to ensure global peace. Too much information delivered too quickly and with too many subtle interconnections complicated political commentary, which in the years of Pop was largely given over to verbal communication such as printed statements, speeches and position papers (many of which were endorsed by the Pop artists). Instead, the artists focused on specific, highly charged issues and images, such as capital punishment and an electric chair, or consumerism and the Coca-Cola trademark, to identify the outward signs of these complex phenomena.

As much as Pop celebrated the euphoric possibilities of consumerism, it also registered the rapid process of change in the post-war world. The American Dream was both a promise and a curse, an expectation that was impossible to fulfil. If the Pop artists were naive in embracing this dream, or at least its media manifestation, then perhaps such naivety was a cautious, and very adult, recognition that the dream existed nowhere except in myth, or in a series of brilliant collages, silkscreens, paintings and sculptures. Instead of providing an ironic send-up of the American Dream, Pop may have been the only place the dream could exist in the post-war years. Too often we find that the Pop artists, mostly in the United States, but in Great Britain as well, were aware that America was riddled with contradictions – great wealth and immense poverty, the ability to enforce global peace and to end the world, the promise of equal opportunity and the ongoing reminder that not all humans were equal. In recording both sides of the American Dream, Pop art revealed the contradictions at the heart of post-war culture.

CONCLUSION

If we judge Pop art according to the few theoretical premises that initially, if very loosely, guided it, then the movement can be judged only a partial success. Lawrence Alloway's radical suggestion that all of human culture could be flattened out into a horizontal expanse of equally weighted images was a significant critical position not completely embraced by the Pop artists. Some forty years later we look at the art as distinct, and somehow better, than its sources of inspiration. Richard Hamilton's famous list of Pop characteristics was entirely incorrect when it came to expendability and low cost. For over a generation Pop has been accorded masterly status by museums and collectors. Claes Oldenburg's desire for an art that did 'something other than sit on its ass in a museum' was not realised. Increasingly we can see his art, or any Pop art for that matter, only with its back against the wall or derrière firmly perched on a pedestal in museums the world over. If we take at face value Warhol's admonition that Pop is liking things, then the sensibility was rightly condemned by critics in the early sixties. Passivity as a viable model for creativity seems shallow at best.

If, however, we allow the works to stand as the material form of the theoretical propositions, we may in fact find that the sensibility of Pop was more interesting, and even more subversive, than was thought possible. The popularity of Pop, which was as immediate as it was long-lasting, licensed many new individuals to take the arts seriously. Here was an art understandable on the surface, yet also deeply resonant to those viewers willing to contemplate carefully the images and contexts selected by the

artists. The images were topical enough in their time so that one did not need a classical or religious training to recognise the iconography. Instead, a willingness to reconsider already known images could lead one to recognise the prevalence of ancient human themes, such as desire and transience, within a world noted for its rapid pace. Moreover, Pop was produced at a moment when more universities, galleries and museums were opening their doors to larger audiences who wanted access to the arts. Unintentionally, Pop became the best advertisement the art world could hope for, and Pop's popularity has continued unabated until the present.

We can see Pop as part of the democratic impulse that sustained so much of the artistic ferment of the sixties. Recognisable imagery in styles that were already largely familiar to people guaranteed immediacy, if not necessarily clarity, of communication. Obvious references to past art, as well as to earlier moments in the twentieth century, suggested that Pop was at pains to examine its time with the help of known markers, whether the movements of Dada and Surrealism, or the visual culture of the Depression and World War II. Instead of an elitist modernism accessible to the few, Pop proposed a new art open to the many. In doing so, it helped relegate a narrow definition of modernism to the past by proposing that the present needed something more.

SELECT BIBLIOGRAPHY

Alloway, Lawrence, *American Pop Art*, exh. cat., New York 1974.

Alloway, Lawrence, *Topics in American Art Since 1945*, New York 1975.

Alloway, Lawrence, *Roy Lichtenstein*, New York 1983.

Amaya, Mario, *Pop Art . . . and After*, New York 1965.

Ayres, Anne, *L.A. Pop in the Sixties*, exh. cat., Newport, California 1989.

Bockris, Victor, *The Life and Death of Andy Warhol*, New York 1989.

Crow, Thomas, *Modern Art in the Common Culture*, New Haven, Connecticut 1996.

Crow, Thomas, *The Rise of the Sixties: American and European Art in the Era of Dissent*, New York 1996.

De Salvo, Donna, and Schimmel, Paul, *Hand-Painted Pop: American Art in Transition 1955–62*, exh. cat., Los Angeles 1992.

Feinstein, Roni, *Robert Rauschenberg: The Silkscreen Paintings 1962–64*, New York 1990.

Geldzahler, Henry, and Rosenblum, Robert, *Andy Warhol: Portraits of the Seventies and Eighties*, London 1993.

Glenn, Constance W., *The Great American Pop Art Store: Multiples of the Sixties*, exh. cat., Long Beach, California 1997.

Goldman, Judith, *James Rosenquist*, exh. cat., Denver, Colorado 1985.

Hamilton, Richard, *Collected Words, 1953–1982*, New York 1982.

Richard Hamilton, exh. cat., The Solomon R. Guggenheim Museum, New York 1973.

Harrison, Charles, and Wood, Paul (eds.), *Art in Theory, 1900–1990: An Anthology of Changing Ideas*, Oxford 1992.

Haskell, Barbara, *Blam!: The Explosion of Pop, Minimalism, and Performance 1958–1964*, exh. cat., New York 1984.

Hebdige, Dick, *Hiding in the Light: On Images and Things*, New York 1988.

Hopps, Walter, and Davidson, Susan, *Robert Rauschenberg: A Retrospective*, exh. cat., New York 1997.

Huyssen, Andreas, *After the Great Divide: Modernism, Mass Culture, Postmodernism*, Bloomington, Indiana 1986.

Jones, Caroline A., *Machine in the Studio: Constructing the Postwar American Artist*, Chicago 1996.

Kitaj: Paintings, Drawings, Pastels, exh. cat., The Hirshhorn Museum and Sculpture Garden, Washington, D.C. 1981.

Lippard, Lucy, *Pop Art*, New York 1970.

Livingstone, Marco, *Pop Art: A Continuing History*, New York 1990.

Livingstone, Marco (ed.), *Pop Art: An International Perspective*, exh. cat., London 1991.

Madoff, Steven Henry, *Pop Art: A Critical History*, Berkeley, California 1997.

Mahsun, Carol Anne, *Pop Art and the Critics*, Ann Arbor, Michigan 1987.

Mamiya, Christin J., *Pop Art and Consumer Culture: American Super Market*, Austin, Texas 1992.

Massey, Anne, *The Independent Group: Modernism and Mass Culture in Britain, 1945–59*, New York 1995.

McShine, Kynaston, *Andy Warhol: A Retrospective*, exh. cat., New York 1989.

Mellor, David, *The Sixties Art Scene in London*, London 1993.

Mellor, David Alan, and Gervereau, Laurent (eds.), *The Sixties: Britain and France, 1962–1973, The Utopian Years*, London 1997.

Modern Dreams: The Rise and Fall and Rise of Pop, exh. cat., Institute for Contemporary Art, New York, and the Clocktower Gallery 1988.

Claes Oldenburg: An Anthology, exh. cat., The Solomon R. Guggenheim Museum, New York 1995.

Robbins, David, *The Independent Group: Postwar Britain and the Aesthetics of Plenty*, exh. cat., Cambridge, Massachusetts 1990.

Rose, Barbara, *Claes Oldenburg*, exh. cat., New York 1969.

Russell, John, and Gablik, Suzi, *Pop Art Redefined*, exh . cat., New York 1969.

Stich, Sidra, *Made in U.S.A: An Americanization in Modern Art, The '50s and '60s*, exh. cat., Berkeley, California 1987.

Tuchman, Maurice, and Barron, Stephanie, *David Hockney: A Retrospective*, exh. cat., Los Angeles 1988.

Vaizey, Marina, *Peter Blake*, exh. cat., Chicago 1986.

Waldman, Diane, *Roy Lichtenstein*, exh. cat., New York 1993.

Watling, Sue, and Mellor, David Alan, *Pauline Boty: The Only Blonde in the World*, exh. cat., London 1998.

Whiting, Cécile, *A Taste for Pop: Pop Art, Gender and Consumer Culture*, New York 1997.

The Works of Edward Rusch, exh. cat., San Francisco Museum of Modern Art 1982.

COPYRIGHT CREDITS

PHOTOGRAPHIC CREDITS

INDEX